EACH IN HER OWN WAY

Women Writing on the Menopause

EACH IN HER OWN WAY

Women Writing on
the Menopause
and Other Aspects of Aging

Edited by
Elizabeth Claman

Queen of Swords Press ▽ Eugene, Oregon

Cover painting, "She Became Dimly Aware of the Sound of Her Own Grief," 52"x 58" oil on canvas, by Jane Orleman, as are all of the paintings in this anthology. An exhibit of her work is available nationally through the Exhibit Touring Service (1-800-356-1256).

Cover design by Elizabeth Claman and Cheryl McLean. Typesetting by Cheryl McLean.

Published in the United States by Queen of Swords Press, 820 E. 26th Avenue, Eugene, OR 97405. First edition.

Library of Congress Catalog Card number: 93-86396

ISBN 0-9638992-0-1 (paperback) $10.95

Printed in the U.S.A.

QUEEN OF SWORDS PRESS is dedicated to publishing books which offer a forum for under-represented voices. Most of our publications will focus on a particular issue like *Each in Her Own Way*, but others will present the work of a single author, and may span a range of subjects. Several books are being projected for the period of 1994-96: the first focuses on the issue of domestic violence, the second will present works on and by women environmentalists world-wide, and the third, writings on and by HIV-positive women. The deadline for materials for the first of these projects is June 30, 1994. Queries regarding other book projects are welcome, but please include an SASE with any communications or manuscripts to insure a response and the return of your materials.

Address all communications to:

Elizabeth Claman, Editor
Queen of Swords Press
820 E. 26th Avenue
Eugene, OR 97405

On April 11, 1992, one of the contributors
to this anthology, Eve Merriam, died.
This book is dedicated to her memory.

ACKNOWLEDGMENTS

Some of the work in this book has previously appeared in the following publications to which the authors and Queen of Swords Press gratefully acknowledge permission to reprint:

"Margenes, cinco," by Lucha Corpi, and its translation, "Boundaries, five," by Catherine Rodríguez-Nieto, previously appeared in *Variaciones sobre una tempestad / Variations on a Storm* (Third Woman Press, 1990); "Lento Litúrgico" was published in *Palabras de mediodia / Noon Words* (El Fuego de Aztlán Publications, 1980). Both are reprinted here with the permission of the author and translator.

"Flash," and "At Night" by Sue Doro are reprinted from *Blue Collar Goodbyes* (Papier-Mache Press, 1993); "Getting Older" from *Heart, Home and Hard Hats* (Midwest Villages and Voices, 1986), all three by permission of the author.

Ann B. Knox's poem, "Aunt from the Country," was previously published in *Carousel*, and in *Stonecrop*.

Earlier versions of "Blood Journey" by Phyllis Koestenbaum appeared in *Birthstone* (1988), and *Networks: An Anthology of San Francisco Bay Area Women Writers* (Vortex, 1979).

Wendy Wilder Larsen's poem "My Place," was published in the Fall 1992 issue of *Poetpourri*, and "Lunch With My Ex" in The *Seattle Poetry Review* (Spring, 1992).

"Vital Signs," by F.R. Lewis was previously published under the title "Signs of Life" in *Permafrost* (Spring 1987).

"The Stripper," by Rachel Loden previously appeared in *Southern Poetry Review*; her poem "Ice Age" in *Midwest Quarterly*.

"The Mothers," by Barbara Lucas was originally published in *The Beloit Poetry Journal*. "Old Women" appeared in *Iris*.

"Ripening," by Joanne McCarthy previously appeared in *Crosscurrents* (Spring 1992), and *If I Had My Life to Live Over I Would Pick More Daisies* (Papier-Mache Press, 1992).

"Toward the Time of My Life," by Eve Merriam previously appeared in *The Double Bed From the Feminine Side* (M. Evans, 1972), and is reprinted with the permission of the author.

Faye Moskowitz's essay, "The Matriarchs Grow Old, My Models," previously appeared in *A Leak in the Heart* (David Godine, 1985), and is published here with the permission of the author.

"Moon Garden" is an excerpt from Charlotte Painter's novel *Seeing Things*

(Context Publications, 1976), and is reprinted with the permission of the author.

Darby Penney's poem, "Mother Road," previously appeared in *The Graham House Review*.

"Almost Fifty," by Dannye Romine Powell was previously published in *Crazyhorse* (Spring, 1993).

"The Choice," by Ingrid Reti previously appeared in *The Pinehurst Journal* (Summer 1991).

Various versions of "Annunciations, October" by Elisavietta Ritchie have appeared in *Visions* (1989), *A Harvest of Maryland Poets*, and *Women of the Fourteenth Moon* (Crossing Press, 1991). Versions of "Clearing the Path" appeared in *The Problem with Eden* (Armstrong College Press, 1985), *Belles Lettres* (1986), *When I Am An Old Woman I Shall Wear Purple* (Papier-Mache, 1986), and in *Flying Time: Stories and Half-Stories* (Signal Books, 1993). Both poems are reprinted by permission of the author.

Willa Schneberg's poem, "Dogwoods at Forty-One," was previously published in *Sow's Ear* (1990).

"Night Melody," by Susan Terence was previously published in *Southern Poetry Review* (Fall 1987).

"DES Daughter," by Joyce Thomas received an Honorable Mention in the 1987 Eve of Saint Agnes Poetry Competition, and was published in the spring 1988 issue of *Negative Capability*.

Gloria Vando's poem, "In The Crevices of Night," was previously published in *Women of the Fourteenth Moon* (Crossing Press, 1991).

Lynne Walker's poems, "For Brenda Star," "National Menopause," "Nellie's Menopause," and "The other day. . ." appeared in *Big Red Burns* (Bloody Twin Press, 1991), and are reprinted with permission of the author.

Special thanks to Jack and Adelle Foley, John Witte, Margarita Donnelly, Jane Todd, John and Holly Campbell, Debbie Diedrich, Robin Hale, Clif Ross, Cheryl McLean, Tom Pringle, and all of the anthology's contributors for their wonderful words of encouragement during this project.

CONTENTS

1 ▽ *Elizabeth Claman*, Introduction

I. BLOOD JOURNEY:
THE BODY'S TRANSFORMATIONS

6 ▽ *Jane Orleman*, Few Secrets Left (44"x 24" oil on canvas)
9 ▽ *Diane Wakoski*, Amaryllis
10 ▽ *Phyllis Koestenbaum*, Blood Journey
15 ▽ *Sondra Zeidenstein*, In This Weather
16 ▽ Late Lilies
17 ▽ *Jeanette Erlbaum Goldsmith*, The Best is Yet to Be
21 ▽ *Willa Schneberg*, Dogwoods at Forty-One
22 ▽ *Lucha Corpi*, Margenes, cinco
23 ▽ *Catherine Rodríguez-Nieto*, Boundaries, five (translation)
24 ▽ *Faye Moskowitz*, Old Woman
26 ▽ *Sue Doro*, Flash
27 ▽ At Night
28 ▽ Getting Older
29 ▽ *Celia Tesdall*, At Menopause: A Diary
38 ▽ *Susan Terence*, Night Melody
39 ▽ *Rachel Loden*, The Stripper
40 ▽ *Barbara Hoffman*, Body Clock
41 ▽ *Marge Miller*, Hot, Hot, Hot
42 ▽ *Lynne Walker*, National Menopause
43 ▽ The other day
44 ▽ *C.K. Freeperson*, Hot Flashes
45 ▽ *Linda Keegan*, Recession
46 ▽ *Emily Mehling*, I, Odalisque
47 ▽ *Dorothy Winslow Wright*, When Dark and Daylight Mesh

II. CLEARING THE PATH: CHANGING RELATIONSHIPS
WITH FRIENDS, FAMILY, LOVERS, OTHERS

48 ▽ *Jane Orleman*, A Dream of Unity: All for One and One
 for All (78"x 60" oil)
51 ▽ *Dannye Romine Powell*, Almost Fifty
52 ▽ *Laure-Anne Bosselaar*, Migration in Red
53 ▽ *Joan Lindgren*, Chain Letter
54 ▽ *Lynne Walker*, Nellie's Menopause
55 ▽ *Diane Wakoski*, Medusa Accompanied by Barking Dogs
 in the City Dump

58 ▽ *Noelle Sickels*, The Memory of All That
62 ▽ *Wendy Wilder Larsen*, Lunch With My Ex
64 ▽ Tugging on the Leash
66 ▽ *C.K. Freeperson*, Eyes with no Age
67 ▽ even now
68 ▽ gramma and love
69 ▽ *Padma Susan Moyer*, Sequins
74 ▽ *Anne Marple*, The Hungry Widow
76 ▽ *Jean Esteve*, The Swamp
78 ▽ *Gloria Vando*, In the Crevices of Night
79 ▽ *Judith Bishop*, Menopause
82 ▽ *Marion Cohen*, This Time of Life
83 ▽ *Arlene L. Mandell*, Holding Abraham
84 ▽ *Elisavietta Ritchie*, Clearing the Path
85 ▽ Annunciations, October
86 ▽ *Sondra Zeidenstein*, The One Dream (A Spell)

III. THE GOOD, THE BAD, AND THE LUDICROUS: MEDICAL INTERVENTIONS

88 ▽ *Jane Orleman*, Ever After (52"x 32" oil on canvas)
91 ▽ *Wendy Wilder Larsen*, My Place
92 ▽ *Brenda Shaw*, The Transformation
96 ▽ *Lynne Walker*, For Brenda Star
97 ▽ *Ingrid Reti*, The Choice
98 ▽ *Elisabeth Holm*, Escaping Eternal Compulsory
 Femininity: The Estrogen Decision
102 ▽ *Gayle Lauradunn*, Different Moon
104 ▽ *Muriel Karr*, Menstruation, Approaching Age 44
105 ▽ *Rosmarie Waldrop*, Winter Journey
108 ▽ *F.R. Lewis*, Vital Signs
112 ▽ *Joyce Thomas*, DES Daughter
114 ▽ *Barbara Lucas*, The Gynecologist's Office
115 ▽ *Bette-B Bauer*, The Revenge of the Menstrual Blood

IV. THE MATRIARCHS GROW OLD: WISE WOMEN

116 ▽ *Jane Orleman*, Protector, Healer, Creator (44"x 34" oil)
119 ▽ *Darby Penney*, Mother Road
120 ▽ *Eve Merriam*, Toward the Time of My Life
122 ▽ *Grace Grafton*, Gardenia wilted skin wild grandmother moist seductive
123 ▽ *Faye Moskowitz*, The Matriarchs Grow Old, My Models
126 ▽ *Julie Herrick White*, Eyes
128 ▽ *Valerie Nieman Colander*, Sidestroke
129 ▽ *Gayle Lauradunn*, Thoughts on a Letter from Arizona
130 ▽ *Lucha Corpi*, Lento Litúrgico
131 ▽ *Catherine Rodríguez-Nieto*, Lento Litúrgico (translation)
132 ▽ *Charlotte Painter*, Moon Garden (excerpt from *Seeing Things*)
145 ▽ *Susan Schefflein*, The Vanity Table
146 ▽ *Laure-Anne Bosselaar*, November Chill
147 ▽ *Marcia Cohee*, Hecate
148 ▽ *Ann B. Knox*, Aunt from the Country
149 ▽ *Hannah Wilson*, Between Floors
161 ▽ *Joanne McCarthy*, Ripening
162 ▽ *Carol O'Brien*, Escapee
163 ▽ Climacteric
164 ▽ *Barbara Lucas*, Old Women
165 ▽ The Mothers
166 ▽ Sunspots
167 ▽ *Rachel Loden*, Ice Age
168 ▽ *Elizabeth Claman*, High Desert

CONTRIBUTORS' NOTES ▽ 171

INTRODUCTION

Entering my local woman-owned copy shop a few days ago, I spotted a poster that prompted me to laugh with delight. "Women don't have hot flashes; they have power surges!" it read. When I told the owner how much I liked it, she made a copy and handed it to me with a grin. I told her I would mention it in the book I was currently editing of women's writing on the menopause, and her face lit up.

"How'd you decide to do that?" she asked.

And I told her, as I do everyone who asks that question, "I just really wanted to know what other women were going through. When I started menopause myself, my experiences didn't seem like any of the myths I'd heard, so I decided to find out more. The result? An anthology!"

Since I began this project in the summer of 1991, menopause has become a *cause célèbre*. Books, radio and TV programs, magazine and newspaper articles, and frank conversations about the intimate details of our bodily changes abound. What a far cry from the secrecy and shame that marked the menopause of our foremothers! We are so candid these days, so willing to talk about what we once kept hidden. The women's writings in *Each in Her Own Way* attest to this new openness, and add significantly to the growing body of literature about this interesting and challenging phase of our lives. As a way of introducing the work that follows, I will share a portion of my own story.

Like some of the contributors to this anthology, I had a hysterectomy in my mid-thirties due to enlarged uterine fibroid tumors that were making me hemorrhage severely at every period, and causing quite a lot of pain. However, because I was under forty, in accordance with standard medical practice, my ovaries were left in place, so although I no longer bled, I still had all of the other side effects of menses. But at age forty-five, when what passed for my menstrual cycle became erratic, I was baffled. One month I'd have three weeks of sore and swollen breasts, a painful ovulation, and PMS, the next three months, nothing—no symptoms at all. The month after, I'd be weepy or angry by turns, or suffer a series of insomniac nights, some with night sweats. And interspersed,

there were occasional hot flashes, which I interpreted as nervous reactions to uncomfortable social situations.

Strange as it now seems, because I had no periods, I had no point of reference from which to understand the relationship between these symptoms and my changing hormone levels. The word *menopause* never entered my mind, for one reason—because I had always thought of it as something that happened to "old" women, and I surely did not include myself in that category. Finally, though, in talking to a woman only a year older than I who described her menopausal symptoms, I realized what my "problem" might be. Sure enough, when I went in for my next pelvic exam and asked my doctor to test me for menopause, we discovered that my FSH level was up, indicating that I was indeed entering menopause. But what did that mean?

It seems amusing to me now how ignorant I was about the menopause. It had been painted as something awful but inevitable that women "suffered" as they grew older, making them uncomfortable and therefore wretched to be around. My then-husband told me about his mother's terrible menopause: severe depression which sent her weeping to her bed daily; my colleagues made jokes about how many menopausal women it took to change a light bulb (in one version: three, one to do the job, and two to rant; in another: only one because if anyone tried to help he'd get his head snapped off). My mother swore that the smartest thing she ever did was to have her uterus and ovaries out at age forty-one and begin taking estrogen immediately because it helped her avoid all of the nastiness she predicted that I was about to face. But what of all of the women whom one never hears about, what did they experience, I wondered.

Once I knew I was menopausal, I began reading everything I could find, and talking to other women who had either already undergone "the change," as some called it, or were currently going through it. Everyone had a story, and what struck me most intensely was that each one was different; every woman I read about or talked to approached and passed through menopause just as she did everything else: in her own way. But my curiosity about this phase of every woman's life was still unsatisfied, and I began brainstorming ways that I could find out more.

As a writer and editor, I thought the most logical idea would be to solicit material from other writers to see if what I received might produce a book that I could in turn share with other women who were in my own situation and curious. So, I sent out a call for manuscripts and there was no question in my mind that the work I received warranted a book. Even now, each time I read it I am moved by the diversity of what women have to say about their aging process. Despite certain general patterns which mark our physical changes during this period of our lives, there are many, many variables. While some women are happy when menses ceases and they are freed from the ritual of monthly blood, there are others who mourn its passing. While some celebrate the new liberties that come with maturity, others grieve for the loss of certain kinds of attention, as well as certain roles and functions that are no longer part of their lives. Some women pass through the menopause so gradually that all they notice is diminished and finally nonexistent menstruation, while others are forced into it radically through surgery, resenting the change, and yet others enter it more or less abruptly at a moment when they are emotionally ill prepared for this mark of aging so derided by our culture. Some women find new sexual freedom once conception is no longer a possibility, while others find sex less interesting for one reason or another. Still others are able to clarify, for themselves and their partners, exactly what they do and don't want sexually—some for the first time in their lives. But what is most surprising to me, as I read through all of the wonderful writing I received, is the variety of emotional responses to the physical changes menopause ushers in. While some women express humor, others become angry, or sad, defiant, or nostalgic when they contemplate their new role and their new physical state. From each of my contributors—those whose names were already well known to me, and those I'd never heard of before—as well as from the many submissions that for various reasons were not chosen for publication, I have learned more about myself, my body, and the ways that all of us as women are both connected to one other, and yet unique—in menopause as in everything else.

By the way, to my great surprise and delight, my own symptoms abated considerably once I was separated from my husband, and even more, once we were divorced. (Could it be, I wonder, that

much of the emotional chaos we all attribute to the menopause is circumstantial?) Now at this writing, I am forty-eight, still in the thick of menopause, yet feeling fit, active, and sexually energized. I suffer very occasionally from the mildest of symptoms—none of which seem severe enough to warrant taking estrogen, despite my doctor's arguments. For the most part, I barely think about my own menopause. I'm too busy with all of my projects, prime among them, completing my doctoral dissertation in Comparative Literature, and compiling this anthology.

As I selected the work I would use in *Each in Her Own Way* and prepared the manuscript so as to shape it into a cohesive book, I found that the writing very naturally broke into the four categories: bodily transformations, changes in the relationships with those close to us, medical interventions, and finally, wise women, which captures a remarkable spirit of transcendence as women come into their mature power and discover ways to make the next phase of their journey rich and vital. But in addition to considering the book's organization, I also thought a good deal about its overall goals. *Each in Her Own Way* does not pretend to be scientifically or sociologically comprehensive, nor is it a replacement for any of the many fine books designed to help women better understand their bodies and the process of aging. Instead, it offers very personal and sometimes private thoughts and emotions about the changes that have occurred in specific women's lives as they grow older. Unlike some of the other works currently on the market, this anthology is not a "how to" book, or one that pretends to offer advice in any form regarding the methods a woman might use in monitoring her progress through the menopause. Neither I nor any of my contributors claims medical expertise.

As a case in point, like all of the medical questions menopause raises, the very important and controversial one of whether or not to embrace estrogen replacement therapy (ERT) is personal, and should be made in concert with whatever competent medical practitioner a woman chooses. Very few of the women who sent me material had much to say in favor of ERT, and although *Each in Her Own Way* proposes no "party line" on that issue, I found the writings I received a healthy balance to the medical professionals' insistence on ERT as a panacea.

Aside from the recent best sellers, like those by Germaine Greer, Gloria Steinem, and Gail Sheehy, there are many fine volumes on the subject of menopause, among them one that I would like to name, because its story—as it relates to me and to this anthology—holds a kind of metaphor for the way that women these days are relating to one another. *Women of the Fourteenth Moon* (Crossing Press, 1991) is edited by Dena Taylor and Amber Coverdale Sumrall. When *Poets and Writers* first ran my call for submissions in the summer of 1991, I got very nice letters from both of these women telling me about their project, then in its final publication phase, and asking if I might need any help in putting mine together. How moved I was by that response, and how different I found it from the business-as-usual cutthroat techniques of our culture at large! I wrote back and thanked them for their offer, and told them I looked forward with excitement to reading their book when it came out. In the fall, as soon as it was available at my local women's bookstore, I bought a copy and read it with keen appreciation. It is a carefully conceived and well-executed volume of rich and varied writing. I treasure my copy of it, not only because it is such a good and helpful book, but because the manner in which its editors approached me seems a valuable example of the ways in which we, as women, are learning to be community for one another in all the areas of our lives. Their words of encouragement, like those from my many contributors, friends, and supporters, have helped me to produce *Each in Her Own Way* and to share this anthology with you.

Each time I read through the work you will find here, I rediscover the richness of its voices which—whether they laugh, rejoice, mourn, rage, or simply recount—do so with integrity and vigor, making me pleased and proud to be part of this complex family of women, and to present *Each in Her Own Way*, which I hope will speak to other menopausal women, to younger women curious about what lies ahead, to older women who might look back with interest at their earlier history, and to the many men, who in these changing times are more willing than they have been in the past to learn about women and to appreciate our complexity.

Elizabeth Claman
August 1993

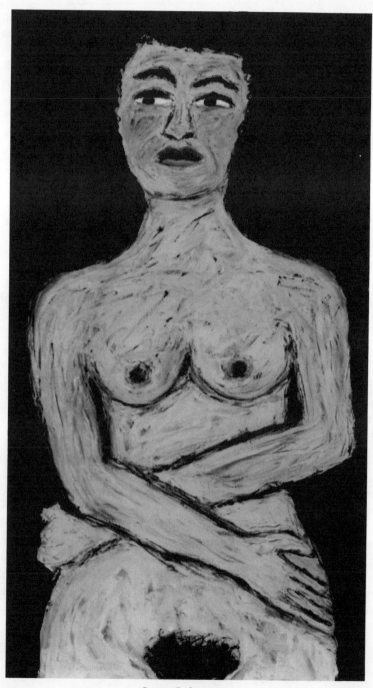

Jane Orleman

FEW SECRETS LEFT

1 ▽ BLOOD JOURNEY
The Body's Transformations

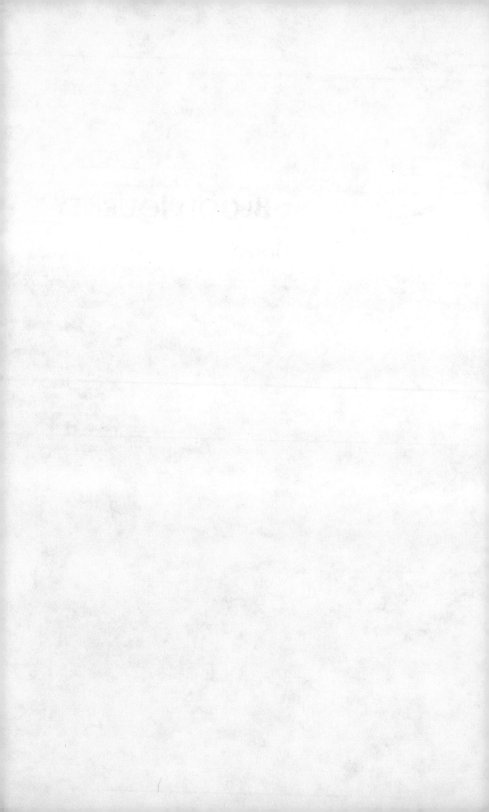

Diane Wakoski

AMARYLLIS

So seldom
do I see myself that way,
any more:
 the trumpet as red as a satin garter,
 the petals like bedroom walls
 or the membrane-thin shade of a bedside lamp,
 a spiky head with a rouged mouth singing oratorios
 or cantatas, waxy-voiced, the candle in
 the window melting now,
into a snowy winter
night.

Phyllis Koestenbaum

BLOOD JOURNEY

1.

A woman on a park bench, fall in the park,
clouds loitering by the lake,
the woman in her brown coat smiles
at birds
who peck at skinny crusts of white bread.

2.

Lights burn all day.
Sun through the kitchen window,
streaked with lamb chops and butterfish, window
to the alley, sun nowhere else.
When lights burn the walls dampen,
lean your head on them, feel their dampness.

I bleed.
Rags, pads, underpants,
jeans, sheets, pajamas, nightgowns,
slacks, shorts,
bathing suits,
a green checked playsuit with a matching skirt.
I am a young girl, I am a young woman,
I go to sleep tired and wake refreshed,
I start again
and again,
I have been everywhere.
I run and bleed a dish of blood.
I shout hello and the blood jumps out as a great breath.
I cannot stop.

My pad drops down from between my legs on the way home for
lunch.
When I go back to school,
the pad is gone.

3.

Spaghetti in a big kettle, an apron on, I am cooking spaghetti.
Such a little woman.
I wish her to leave, I am busy,
I am always busy.
My floors are warm and swept, my children will be tall.

When she dies I lock myself out of my house
for punishment; I go to the doctor, tell him
my chest hurts; I am afraid something is wrong with my heart.

4.

My uterus is a clay pot
with ridges like doll carriage tires.

I do not menstruate this month.

Running to the bathroom to check, wiping with
public bathroom toilet paper, praying to see red
on the cheap paper, praying not to be
pregnant, years of running to bathrooms to check.

You blotted your lips, on binder paper if that's all you had,
your lipstick was deep as a rose,
the husky red of a rose.

The blood gathers, aching to pour,
warm milk from a cracked pitcher.
Twice I tried nursing but the milk wouldn't let down,
the baby sucked and got nothing.
My doctor warned: switch to a
bottle or your baby will starve.

I may never menstruate again.

My father said no more fairy tales.
He told my mother, she must grow up.
I went to the 42nd Street Library with him Saturday mornings.
Gold ran down the closed pages and when you opened them
only the edge was gold.
The smell of the fairy books, the smell of the children's room.

5.

I sneak looks at young girls in class,
women my age at the market,
decide which are menstruating. In high school
we spotted the girls who had done it by their walk,
how far apart their legs were.

The mirror sends me back my face.
Didn't my father caution me against frowning?

I try to remember how old my mother was
when she no longer had it. We called our period it,
not curse or monthly or bleeding or
that time or that time of the month
or period.
It.
Do you have it
yet? Is it
over? My mother's tumultuous periods, circles
on the mattress with loose buttons, the window
open, airing the mattress.
If I phoned her to ask how old she was when she
paused, she would say, you shouldn't be stopping
now, you're too young.

The truth is
my not bleeding is an unnatural
halting. I am not a normal woman, I have always been
selfish, even in sex
part of me won't join.
I hide in my dark center;
there, alone, I remain a virgin.

6.

The others
who buy one quart of milk
a carton of cottage cheese
a small can of apricots
half a pound of ground meat

sometimes a 6-pack
their order fits in one bag
they don't need any help out
their heads their poor heads are wire coat hangers.

7.

I bargain:
blood for poetry.

8.

Blood is
poetry.

Who
will I be without my blood?

A bleeding woman.
She surges as the earth does.
She swells, shrinks.
She murmurs.
She sings.
Her life is a dance, her arms command
but also beseech.

See her
seated in the circle of herself.

A bleeding woman bleeds in meter.

9.

Consider a poem. Cup
your hand, put the fingers of the other hand in
the cup, nothing to be felt, nothing to be seen only
the lines of your hand, what is in the cup doesn't
smell, will not go up in flame.

The odor of blood on napkins,
the odor of the ground, if you put your nose to it as dogs do,

scratching and sniffing.
The fire from ripe bodies is a stench.
Books also burn.

What is in the cup of your hand will not leave;
under your feet, behind you,
it turns,
but it doesn't breathe.

10.

When the thunder came I swore I would be good.
When it went, I shuffled into the bathroom
and peed
then listened to my mother
peeing.
The next day I was bad.

11.

The woman who walks with her cane every afternoon unless it
rains,
her face on her chest, the bulge of her old spine.
Her friend walks with her,
she has white hair and always wears
an apron; she waves to me as I round the corner.
I wave back.

12.

Underclothes soak in cold water in garage and bathroom basins.
My blood ravishes me, giving me nothing.

Sondra Zeidenstein

IN THIS WEATHER

This is a juiceless August.
I sit by the pond turning pages.
Frogs dangle brassy-eyed.
The root of my tongue is raspy,
my tongue cleaves to my rough dry palate.

I do not want to come upon these photos without warning,
grainy, low contrast, two dancers, I think,
their bodies connect in odd poses:

one woman's wrist inside the other's thighs,
the other arches her back, large breasts straining—

one woman's long hair covers the thighs of the other,
she, the sucking, licking woman, reaches with thumb and
 forefinger
to touch a beseeching nipple—

the faces are tender, lids closed, lips upcurved and parted.
I turn the page sharply.

I do not want to be forced in this weather
to look in the face of a woman wet and flowering.
I want to forget rain forests,
sticky blossoms spilling their sex for luminous moths,

how the mouths of the young flood with saliva,
how it wells up under the tongue like endless springs.
My tongue thirsts for words now, for sound shapes,
a rush of naming, as once it thirsted for kisses.
I am desperate when they do not come.

LATE LILIES

I rest my eyes on these lilies I took from their last
 August stalk as pods, yesterday, erect.
They have opened in the heat, their petals stretched back,
 back, like my knees once, pressed back against my shoulders
Three late lilies in a saucer.

I want their purple-flecked, creamy, curly-edged petals
 (like stretched crepe paper), their spilling sex,
 their aggressive perfume, to last forever.
Nothing will be so unashamed after the lilies.
They ask for it. They want it.
Long past my dry, just-as-well-do-without-it, sexual lips.

I could read porno or women's sexual fantasies collected
 to moisten my linings.
But what for? Sex bores me. Passion is gone.
The rubbing is just rubbing. Uninspired. Like soggy tinder.
This is no country for old women—large-pored, and thin-haired.

I got out of the tub and saw in the mirror—I was so
 shocked—I had no hair there.

Nibbling, yes.
Little fish nibbles at the pale dry tissue of each other's lips.
But why bother? I have forgotten the trick.
My breasts are not soft or upcurved.

Creamy white lilies with yellow furrows.
Exotic shantung flesh.
I have forgotten why we rub our lengths against each other,
 part the flesh.
I am aware that only his eyes are young, their small wetness
 in his scored face, the sea of all his tenderness.

And yet I reach for his thin, hard embrace, the shampoo
 traces of flowers in his brusque hair, the rasp
 of his tongue, the odd pink bubble of his nipple,
 the memory, faint, beseeching, of a silver arcing
 out of the sea.

THE BEST IS YET TO BE

You're almost fifty, you devil, you, and people say you don't look a day over thirty—thirty-five. But you're too smart to believe them.

My childhood friend is nine months older than I. She's had to face twenty and thirty and forty first, always first. Although I always reassure her that I'm right behind her, just coming around the bend. I feel younger, haler, more fortunate—all because of those nine months. What could be sillier?—Yet she, wouldn't you know it, feels the same way, thinking of me as younger, hardier, luckier, wishing, I know, that I had been saddled with those nine months first.

My husband looks better than most men his age. Lean as a wire once, he's heftier now, substantial in an appealingly paternal sort of way. His grandchildren, ours, think of him as a big man, even gigantic, though he's no more than average in height and build. He's only slightly reproachful that I no longer look as I did when I was sixteen, when we first met, and I have long reconciled myself to the disappearance of the *enfant terrible* he was during the fleeting period of his extraordinary leanness.

I grow more and more cowardly with age, though I haven't lost my fondness for cemeteries. I've always felt strangely at home there, strangely, or not so strangely, at peace. It's only the sight now of blood, examining rooms, life support-systems, hospital corridors, stroke and Alzheimer's victims, surgical supplies, nurses' uniforms, toy doctor's kits, that terrifies me.

You brood, you mope. You don't listen when I tell you it doesn't matter how old you are, as long as you look good. And you look

better than ever! You were no great shakes in kindergarten, or at thirteen, now, were you? And then, nineteen through twenty-five, when you were having all those babies, how wonderful did you look then? Not much better when you were rearing them up—never a minute for yourself. Now you can groom to your heart's content, groom, groom, and listen to me, darling—it shows!

My college friend—we've been close for twenty years—insists I look the same as when I met him. Yet I can see the changes in him. He looks handsome, far younger than his years, but the tell-tale signs of aging—around the eyes, the ears, the throat—are unmistakable. I put two constructions on his insistence that I haven't changed: 1) He's lying to spare my feelings; 2) I'm frozen in his mind's eye as a twenty-five year old woman and he'll never see me as I really am.

I'm at the age when my girlfriend's son can kiss me without being embarrassed, when he's old enough to enjoy the effect of his firm and supple body on my aging libidinous eyes—when he's kind and cruel enough to invite, "Here, pinch," the unfallen ass his mom has extolled, as if to say, "Not to worry, you can't turn me on."

You look in the mirror a lot now—even if it's an unkind one—there are so many unkind ones, and they're getting unkinder all the time. Your husband mistakes it for vanity, as if you could still like what you see. But you don't want to be taken unawares any-more, as with those lines you never saw coming. That one across the bridge of your nose—what an unmitigated horror—and you weren't even thirty. Is it possible that if you stood in front of the mirror without falling asleep for the next twenty-five years, you wouldn't look a day older?

We go out occasionally, my college friend and I, with the bless-ings of our respective spouses, neither of whom was an English major, each relieved to escape the reading or lecture which at-tracts our mutual interest. There's often a sense of excitement in these meetings, an unspoken mutual pretense at romance. We are as solicitous of one another's feelings as new lovers, each fully at-

tentive to the other and scrupulously avoiding the attentions of strangers. Of late, however, I have noticed his eyes wandering the crowded room and catching irresistibly on some flawless young bottom in jeans, returning finally to my face with an expression of unmistakable guilt. An old face, I realize ungrudgingly, is no competition for a young ass.

What a handsome man! Is he the owner? I never used to look at men with gray hair before. He's smiling at me. You see, exciting things can still happen when you least expect them. Such a handsome man. Tall. The gray hair really suits him. Still smiling. What vibes I'm getting. I'm tingling all over. He's coming around the counter to open the door for me! I don't believe it! "Thank you!" I don't suppose he'll be there again when I return to pick up my clothes. He was never there before. No matter. The important thing is that exciting things can still happen.

My girlfriend's daughter is getting married. The couple is religious and they don't believe in touching before marriage. He recites biblical passages into her ear, sings religious melodies at her command. Her face, bathed with his hot breath, is swathed in enraptured brazen smiles. They stare into one another's eyes, oblivious to antagonistic siblings, eyeglasses only touching, horned frame to horned frame.

Maybe I will see him. I wonder if the vibes will be there again. There he is, in the street! What luck!—Is he leaving? No, he's turning inside. But his face...he looks old! Where did those lines come from? Maybe he'll look better in the store. No, no better. He's slipping on his eyeglasses to examine my ticket. He's going to the rack for my things. There's a little stoop to his walk. He's flashing that mean smile. It's really sweet. But it's not doing anything for me. He's getting the door again. "Thank you." He's old. Old.

Most recently, a woman beside me, perhaps younger than myself, leaned over me repeatedly to question my college friend about the reader we had come to see, if my friend was familiar with his work, had gone to see him before, and so on. He responded with

his most charming and gallant manner, looking over at me guiltily each time.

Oh, what a horror. Why hasn't anyone told me how dreadful I look? I've never seen so many lines. Where did they come from? I shouldn't have worn this color lipstick. Too hard. Makes me look older. Oh, Sandy—how could you? She thinks it's kind to deceive her mother. My face is sagging. My whole face is absolutely sagging. "Did you want to get by with your wagon, sir?—Sorry." So absorbed, I was blocking the aisle. But why do they put mirrors all over the damn place?—Why?

When Sandy walks down the street—this is no mere motherly boasting—every eye, I repeat, every eye becomes glued. She has "beauty to make a stranger's eye distraught," and friends notwithstanding. When I walk beside her, I swear, I take a maternal pride in my invisibility.

I had a dream. My husband was dancing naked. He was a regular Baryshnikov with no clothes. Leaping, bounding, whirling, twirling—his body was red and bathed in sweat. He was showing off for me. He spun, he twisted, he cavorted. I was laughing uproariously. The tears were running down my face even as I awoke.

Willa Schneberg

DOGWOODS AT FORTY-ONE

Although her period is heavy as usual
and requires two tampons and a pad,
she pauses this time
before flushing
the blood-clotted paper
down the commode to watch the red
dye the water.

At forty-one she is surprised
she is happy with her queasy stomach
and swollen breasts,
although she never wanted children.
But now it isn't enough for her
to observe dogwoods profuse
with pink and white petals
from her window,
she must take them inside,
filling every glass in the house
with their short-lived beauty.

Lucha Corpi

MARGENES

Cinco

Cuesta envejecer
sentir la sangre titubear
en su cauce mensual,
imaginar la luna
que me ha ido dejando atrás,
la misma luna que completa
quinientos sesenta ciclos ya
y seguirá su rumbo consabido
cuando de mi sangre
intempestivas
queden sólo la sal y la palabra.

BOUNDARIES

Five

It's difficult to age
to feel my blood falter
in its monthly course,
to think of the moon
beginning to leave me behind,
the very moon that is now closing
its five hundred sixtieth cycle
and will continue on its appointed round
when nothing of my blood remains
but untimely
salt and word.

Faye Moskowitz

OLD WOMAN

Old woman, reminder,
string around my finger: make
your bed, why don't you. Cover
the towel that protects
your sheet at night when cats
in heat howl and all things
let go, but sleep.

Teeth: memento mori
in a yahrzeit glass
wait in murky water
'til the time for garbled bulletins:
rapes, bombings, murders, fire.
Every day is Yom Kippur.
Only the pain is accurate.

Listen: the cat
wouldn't jump in your plate
if you didn't feed him hourly.
You're killing him, you know.
Hardening of the arteries, diabetes,
ulcers—all your Jewish diseases.
He can live without such favors.

Clean out the refrigerator.
The boiled potato
flowers; the saucer
of rice blossoms, while
on your windowsill,
plants die from
too much water.

What good the warning?
Shoulders hunch under turned-up
collars. . . even when they're naked.
The years fall like stones.
Who can stave off morning
when flesh will reverse itself,
fall away from the bones?

Sue Doro

FLASH

hot face
spinning iron
ears burning
heart pounding
mouth dry
scalp itching under my hard hat
sweat dripping down my cheeks
safety glasses sliding off my nose
trying to get the last damn axle of the day
cut and on its way
in the middle of a heavy hot flash
and here comes my friend Earl
from the machine next door
zipping up his jacket
to ward off forty degree indoor
winter factory wind chills
he gives a knowing grin
and motions me to sit down
on the overturned barrel
behind the lathe
while he takes over to finish the job
 as for me
 i don't say no

AT NIGHT

the hormones wake
to dance and party
naked in the rain

i try to tell them
shut up
i gotta get some sleep
i gotta go to work tomorrow
for pete's sake
shut the racket down
but they don't listen
they set fire to my feet
and pour buckets of rainwater
all over my body
except my feet
which by now
feel like fried sausages
sticking out of wet
fuzzy blanket buns
so what's a woman
supposed to do
but get up outa bed

and dance

GETTING OLDER

smiling through 47 years
i cook eggs for breakfast this morning
taking a necessary day off from the factory
i bite into my toast while thumbing through
OUR BODIES OURSELVES
chapter 17
Menopause
then i have to go to the bathroom
and get my partial plate
that i left in its little blue plastic box
soaking overnight
in baking soda
in the cabinet under the sink
because without all my teeth
the toast in my mouth
is too difficult to chew
and i laugh with myself
seeing myself holding a piece of bitten toast
reading about menopause
and hunting for false teeth
because what i'm looking for
in chapter 17
is how to best keep on making love at 47
with a vagina that tends to dry a bit
and good old OUR BODIES book
answers with
saliva
KY jelly
and a loving partner
so as soon as i finish my eggs
i'm on my way to the drugstore
to get the one i don't have

Celia Tesdall

AT MENOPAUSE : A Diary

December 12, 1984. I've decided to keep a menopause diary while I'm going through the process. None of my friends seem to want to talk about it much. Older women, when I ask about it point blank, take on a vague look and say: "Oh, it wasn't so bad." Others nearer my age are simply silent. Apparently all of us are embarrassed by it; so are our doctors. But since women's life expectancy is coming up on 80 and menopause may occur any time from 40 to 65, it will soon be the case that half a woman's life is post-menopause. Still the picture of the postmenopausal crone stays with us.

I'm 49. I've had regular periods since 14, ranging from 5-week intervals to precisely 28 days. I've never had bleeding between periods except a trace, which I associate with ovulation. I had two normal pregnancies resulting in two daughters who are 28 and 21. I've had a large fibroid tumor for at least 20 years. This has never caused me any trouble except that it presumably contributes to premenstrual discomfort: it expands and shrinks monthly. For 15 years I've walked for exercise, which helps keep me generally healthy and my abdominal muscles strong. I'm up to 20 miles a week.

Last year Doctor M., a man ten years older than I, shocked me by saying I should have a hysterectomy as soon as possible, though he hadn't seen evidence of cancer or any problems except size. When I asked him why, he said of the fibroid: "It won't go away." He wanted me to have the ovaries out as well, saying that their only effect from now on is to be a source of potential trouble. He meant cancer, of course. But I'd always been told life would be easier with the ovaries still there, at least till menopause is complete.

So far I've resisted his pressure and he's clearly irritated. Is this an unworthy suspicion? I attribute his sudden change of mood after 20 years to the presence of a new surgeon in the practice. They've never had one before, and I think this man may be having a hard time getting established. Other patients report a similar change. A woman I know slightly has had a hysterectomy, done by the new guy. I don't know her well enough to ask her about it.

Besides, how will it help her now if she is tempted to have second thoughts?

March, 1985. I missed my February period but had a normal one this month. I've always had some water retention, some mood swings (my family would say yes to that!), and some cramps the first day. Length was almost always two heavy days and about three light ones. This continued unchanged till October and November of 1984. After the October period I had spotting for about six days, after which the fibroid seemed to be considerably reduced. It be-gan to build up again almost immediately. I thought I was missing my November period; I was involved in an emotionally draining trip at the time it was due, and I thought back to my wedding trip (yes, I was a virgin), which was the only other time a period was late except in pregnancy. I've wondered whether you can "think" your period into delaying.

The November period finally came, about three weeks late, just at Thanksgiving. That too was a low point in my life; I was worried about my younger daughter, who seemed too depressed after the breakup of a relationship. It seemed my period was never going to stop. I thought it had when I had four clear days from the 25th to the 29th, but I started bleeding again on the 30th and went on till the 4th, almost as if I'd gotten both periods, only two weeks apart. I wasn't prepared to ask the doctor about it yet, be-cause I knew he'd be only too pleased to whisk me into the hospi-tal for that hysterectomy. (Question: how long do you wait before calling the doctor, especially if he's knife-happy?)

At the end of the second siege I could barely find the tumor by probing in my abdomen, and when I did my own internal exami-nation I found the cervix was relaxed and flaccid, so I must be in at least the first stages of menopause.

I've felt remarkably good since the bleeding ceased. There has been no trace from then till now. I have never had what could be called a real hot flash, if I understand them. I said I'm well, but I have to admit I do tend to be unusually anxious these days. I'm not sure whether this has increased since the periods started get-ting irregular. I have to face it: I'm an anxious person by nature.

December 13, 1985. Strange: a lot of vaginal mucous and a greatly enhanced sense of smell; the latter means I can hardly bear to be in a closed room with a lot of people. I remember this used to

be a major irritation to me at the beginning of pregnancy. No! I'm not pregnant! I'm not!

February 1986. I wasn't. I got a clean bill of health from the doctor and a tacit permission to monitor the tumor myself. (Guess what: he no longer has a surgeon in the office; the guy didn't make it.) But he tells me it's the size of a large mango—he said grapefruit last time. Ever since, of course, I've been feeling full and uncomfortable.

February 16, 1987 Last year I had regular periods till June: no period, due at the time of a writer's workshop I was convening; July: very heavy period; August: no period—due at the time of another workshop—until: a very light period beginning on the 31st; September: regular period beginning on the 15th; October and November: no periods; December: light period; January: nothing but a trace; February: period, heavy but not long.

I feel blah a good deal of the time but no hot flashes. I wish it would get on with it, but then again I have mixed feelings. The two of us have some unfinished business about sex. It happened again this morning: I waited till S. woke up and then kissed him on the nose. I had no conscious feeling that I was promoting sex. I didn't feel horny. What I think I was saying was: "I love you and I feel fortunate to be waking up in the same bed with you." Did I misread my motives?

It made him want sex, of course. And I wasn't really opposed. I figured it was the safe period and so didn't get up to put in the diaphragm. (That kind of reasoning got us two kids.) When we were through I reminded him of the condoms I'd bought and put in his bed table, and asked him to provide for the contraception the next time he was the one who initiated sex. He got that funny look he always gets and mumbled something about condoms interfering with "everybody's" pleasure.

How can I get it across to him that it has no effect on my pleasure at all? And what does he think it means—and has meant for 30 years—to me to get out of bed and put in the diaphragm. As a feminist, I've always been convinced that liberation can proceed within the circle of a good marriage. But once in a while I glimpse the reasons for radicalism. How dare he get "that look" when I suggest he be responsible for contraception half the time! How dare he say, "It's like taking a shower with your raincoat on"!

Is it a case of the shoemaker's children going shoeless? He runs the Counseling Center at the University. His clients respect him; he hears good feedback even from the Women's Center. He's always telling me—without names, of course—about people who come to him with dilemmas remarkably like ours. Especially now in these days of AIDS he's ferocious with them if he finds they haven't been using condoms. Alas, home is different.

I have to admit one thing, though, one important and wonderful thing about my husband. About 15 years ago he pledged that he would never again try to coerce me into sex. We have it when I want it, which is roughly one third as often as he wants it, and I know it's not easy for him. Do we have a trade-off here: if I'm always the initiator, does that mean I should always be the one to guard against conception? Am I upping the ante too much?

What a downer, what a damper on desire, were those ten years early in our marriage while I let him initiate sex and he "let" me do the contraception. Those were the years when I couldn't really dare to say no because I had it firmly in my mind that "men need all the sex they want inside marriage or they will be justified in going outside the marriage for it. This is their right." Slowly I learned that I must give up the worry in order to become a whole person, whether we stayed married or not. At the same time I recognized that he was getting something more than sex out of our life. I learned that he loves me.

Big question: when menopause is complete, will he feel he should go back to initiating sex? Probably not; he's a very smart man. At least where frequency is concerned, he couldn't fail to make the link between all that wonderful advice he gives his clients and his obligations to me. But how long should I keep pestering him about the condoms? Nice as he is, he literally sneers every time I say the word. What would happen if it occurred to him he could have sex several times a week with condoms? Would I accede to this? I guess we'll have to wait and see. Talk it all out? That's never as easy as it sounds, especially in sexual matters.

May 20, 1987. I suppose these lightning mood swings are menopause? It seems I have less and less tolerance for other people's shit. Recently I've made a change in our getting-up routine. I now wait patiently for S. to get up first and get in the shower. During the shower, I get up and make breakfast. It means I no longer have to

get up in the dark so as not to disturb him, get the meal on the table, wake him, and then wait a long time till he drags himself out of bed. It's so good for my soul! He hates it; he keeps trying to go back to the old pattern. I make him set the clock for exactly when he wants to get up. He forgot on Saturday night and I went to church without him. Not a word passed between us about it. Marriage games.

My life has been a continuing process of learning to refuse to do what gave me only hassle while it benefitted him. (I no longer drive to the airport, which means I no longer have both the anxiety of his absence and the boredom of the hour trip back alone.) The altered sex life is part of this process of liberation.

February 17, 1988. No periods, June-August. Then one the end of September which went on so long I really got worried. It did stop. No period till November: heavy but not long. Heavy one in January, which lasted a little too long. Much more bloating these days, but almost no cramps. Many mood swings; I take PMS pills. Some sleeplessness, so I often end the night in the bed in my study. What freedom in knowing I can read all night and disturb nobody. I remember the days when I used to be sorry for couples who had taken to sleeping in different rooms. Our sex life is lovely, though infrequent. (For a man, can a sex life *be* lovely if it is infrequent?)

Spring, 1988. O.K., crunch time. This is the worst since a year-long depression in my thirties. Is it hormones, menopause? I feel an abiding despair, mostly for the kids. How can they retain the idealism—and even arrogance—which keeps them going, assures them they can make the world over, even if their parents have failed? Our eldest assures me the world is not the way I see it. I need to be told this often: that my world-view is the aberrant one. She too has had a romance which went nowhere, because the man had nothing to offer her but his need to get her into bed. When he accused her of being a mama's girl she ordered him out of her apartment.

I'm having periods, not too heavy. Bad bloating, sensation of PMS for at least half the month, much more pronounced than before menopause. Vague suicidal impulses, or rather a vague wish not-to-be.

August 16, 1988. No period in July and none yet in August. The despair has receded, but still plucks around the edges of my mind.

January 1989. A rough few months. *Bad* moods. No periods since July, till heavy bleeding just at the end of October. It lasted 16 days, not so heavy after the first week. Then no more periods to date. I believe I may have experienced some mild hot flashes. Outer lips of vagina feel thin. Trouble with dryness, itching, especially after intercourse. I don't use soap for washing, and even too vigorous washing with plain water and washcloth can bring on the itching. As of now, the uterus and fibroid are at their smallest. Good to think I may possibly avoid hysterectomy, at least in the short run.

June 7, 1989. No periods except a trace in May which I'm tempted not to count. I'm telling myself that for the first time since 14 I've gone six months without a period, pregnancy aside.

August 2, 1989. No period, but PMS and bad, low mood, retention of water through most of July. I felt bloated and ugly; my clothes don't fit. When I'm in this state, all I can think about is "When are the bad things going to start happening?"

But a few days ago, I had a strange feeling: cheerfulness began to work at the edges of the mass of anxiety inside my mind. For the time the adversaries sparred, till it became the anxiety's turn to be peripheral. That is my present state, and it feels good.

My work mornings are livelier, though sometimes the temptation to substitute physical for thought work is irresistible. Yesterday I pruned shrubs when I should have been writing an article.

For the last year or two my dreams have all been crowd scenes: in communes, shopping malls, huge cocktail parties, everything I hate. Why don't I dream of being alone in a house with a view of the sea? At any rate, for the last week or so, the crowds are still there, but in the midst of them I'm participating in or listening to something interesting and stimulating, usually in the presence of just one lively person picked out of the crowd.

Another hopeful development: I've been greatly troubled by short-term memory loss for the last year or so: forgetting how to spell common words, how a knob turns, what I went to the kitchen for, etc. I've spent a lot of time worrying about this, being sure I have Alzheimer's like my uncle. This syndrome has now receded a good deal, starting in June when we were travelling a lot. Is this memory problem in healthy people in their fifties made worse by worry and by testing it too often?

August 24, 1989. Two months to go to infertility. Is this a meno-pause diary or a chronicle of a sex-life? There are several things about sex and genital life which I've learned the hard way.

I always urinate immediately after intercourse. The female ure-thra is short and the activities of sex tend to force bacteria into it. I haven't had a case of cystitis since I learned this. But it's clear I can't wait till morning, or even a couple of hours. I do it immedi-ately, and I've discovered it's almost worth storing up a little urine in order to get a good flow. (Ah yes: the woman always pays, both coming and going!)

I don't use soap on my genitals. I wash gently with only water and a soft washcloth and I don't scrub at all. (The French know all about this; hence the bidet.) As the tissues get thinner and drier I've learned to allow natural fluids to lubricate the area. I don't douche, not even after my periods. I don't (didn't) use pads or tampons with deodorants. I don't smell bad unless I'm sick. The genitals know what they're doing!

At the start of menopause I had a full physical: Pap test, blood work. Then I resolved not to go to the doctor every time I had a wacky period. I assumed that the weird things which were hap-pening to me were normal menopause. (Would I have known what "too much bleeding" was? I think so; I hope so.)

I exercise a lot.

As a young woman I let myself believe the prevailing senti-mental theory that love and sex are interchangeable in marriage. For a long time I've known better: love is love and sex is sex. When we're making love we're having sex. Love is what S. feels for me while he waits for me to get around to being horny. Love is what I feel for him while I'm livid with him for not using a condom.

To have an orgasm, I need external stimulation of the clitoris, which in me is located too far from the action. (Is this one more joke played on the female by a sexist male God?) If through suffi-cient foreplay I am teetering right on the edge as intercourse be-gins, I can sometimes balance over, but I always need help before-hand. I'm so grateful we learned this during the first year of our marriage. Part of the reason S. is such a good sexual partner is that he takes for granted his part in bringing me to orgasm.

December 10, 1989. One year since I had a menstrual period. However, all the manifestations of my cycle are present this month:

horniness two days before period time, retaining water, painful breasts, depression, and irritability. Only I don't bleed. I have decided that it would be overly careful to assume I'm still fertile, so: end of contraception. I will continue to use the spermicide for lubrication, probably as long as I have sex. When I go to pick up a supply at the drugstore in my 80s, will the clerk look at me funny?

My mother died in June, at 86, of a heart attack. I know from small hints she gave that she was sexually active into her 80s, during which she had several bad bouts with cystitis. How I wish I'd caught on in time to tell her it probably came from intercourse and could be prevented most times by the urine trick. But would I have had the courage to do it? Ours has not been a confiding family.

So far S. hasn't pounced on me. Now we're into the first days of the rest of our lives, how is it going to sit with me that I am to time our sex? Too much responsibility? I don't think so.

November 18, 1990. I have a friend about ten years older than I, who had a hysterectomy last summer after the muscles around her uterus let go. She still suffers from incontinence as a result of something they couldn't—or didn't—tack back into place. Her female surgeon, whom she picked so carefully and drove so many miles to visit, says airily: "We aren't miracle workers, you know. Some of this is just aging." Is this true? Could my friend have found a more careful surgeon? Does she have to be incontinent?

One of our daughters is married now and the other has a steady sexual friend. Do their men use the raincoat defense, or has AIDS brought all that nonsense to an end? Of course I'm afraid to ask. I'm going to go on wondering till the day I die.

January 1, 1991. A full two years since I've had a period. But I still get breast pain and water retention, still take PMS pills for anxiety and grumpiness. S. still lets me time sex. In no way did he take advantage of my infertility. We sometimes go two weeks between times, but it's still fun for us both. I nearly always have an orgasm, externally stimulated.

I've had two Pap tests since the periods stopped, both normal. The doctor has capitulated and "given me control" (!) over the fibroid. "It's no bigger," he says. It certainly isn't; my stomach is flatter than since before our second was born. I walk and walk and walk. It feels good. I don't have to get up at night to urinate, even

if I'm awake for other reasons. (I realize this probably means luck rather than skill on my part: the fibroid and the bladder just happen not to be dangerously interconnected. This is different in other people, and I presume it could change in me at any time.)

I have been through menopause. The weird periods were normal; they did not indicate a need for hysterectomy.

A caveat: perhaps I could have held the depression at bay better if I'd been taking estrogen. Some of my friends swear by it. But it is also suspect in some kinds of uterine cancer. My doctor would have been delighted to put me on it, *after* hysterectomy. For now, at least, I'd rather be without it. For my bones, I walk and ingest calcium.

What has been the subject of this diary in which I planned to cover only menopause? Sexual life. Marriage. Genital hygiene. Feminism. Existentialism. All these and more. We can't separate the strands. In many ways the sentimentalists who wrote the marriage manuals of the 1950s are right and I am wrong. Love and sex are inextricable, one from the other, in my life.

Susan Terence

NIGHT MELODY

Sometimes when the night air
is thick like clabbered milk
and I can't sleep, I walk
outside in slippers so as not
to wake your father. I
lift the leaves of withered
tomatoes and say, "How
are you doing, kids? Downcast?
Not too well? Pick up."
And the crickets resting
on stalks of crenshaw melons CHIRP,
"Bye-bye, Mother. Bye-bye,
bye-bye," and I start to cry.

At 4, the air turns cooler
like a damp cloth, and I can hear
neighbors' cats hitting branches
like switches, lizards slipping
on the leaves. Monkeys
keening in the cages
next door. Sometimes, a
swatch of music curls
from an open door. Woodpeckers
tap the phone poles at 5
and plump mourning doves
perch coolly on phone wires.

Your father wakes, doesn't know
I've been out walking. He eats
breakfast, reads the paper, empties the compost
and I weed the strawberries, re-string the beans.

Rachel Loden

THE STRIPPER

I am the woman
in the mirror
undressing,

I begin
to pare my body,
rolling the soft breasts
down to the belly, over the hips,
peeling down my legs
until my body lies
in a circle around my ankles.

I step out of the charmed circle
of my fallen body, I am an invisible woman
from the shoulders down,
my two arms wave like giant pincers

and it is moonlight, I am hanging
my body on a line with clothespins,

it is an old bag, a broken-down
dreamskin, a dilapidated girdle
pickled gray with washing . . .

Barbara Hoffman

BODY CLOCK

in the middle of kisses
kisses hot kisses
legs wrapped
 a hot flash
layers my skin
with a sheen of sweat

in the air-conditioned office
the vice-president clicks in
frowning, bristling
the sweat kicks in
my face flushes
with the liquid surging
under my skin

at night, sweat hotflashes
me awake, pools
in the crooks
of my elbows
creeps out
from under my skin
clinging to my body

my body, screaming
the clock is too fast
this shroud of sweat

Marge Miller

HOT, HOT, HOT

Through the coolness
 of the air-conditioned office,
restaurant, bedroom,
 it comes:

First, a click,
 like a doorknob turning
 in the middle of a dark night,
a match scrapes across the heart,
 lighting a fire that spreads
 throughout the body.

Blood bubbles, boils,
 heart pumps faster,
 pulse races,
 face reddens,
molten lava sweat
struggles to cool this meltdown,
 ashes cling to clammy skin.

And the air conditioner hums,
 I enjoy being a girl.

Lynne Walker

NATIONAL MENOPAUSE

"Baby Boomers experience
premature menopause."

It's official,
I heard it on McNeil-Lehrer.

They reported on
the lack of interest in sex,
growth of facial hair,
softening bones,
shrinking vaginas.
Did they mention memory loss?

At the office
we're embarrassed
when a flush of fever
hits the back of neck,
seeps into face,
turns it maroon.
Sweat drips,
we take our jackets off,
put them on,
take them off.

40 million women are having fits.

We thought we'd always
be little darlings.

THE OTHER DAY

The other day
I had an orgasm
and a hot flash
at the same time.

It was fantastic.

C.K. Freeperson

HOT FLASHES

Hormones
hold me
hostage
red cayenne
face
rushes
like inverse labor pains
silently
tap me on the back
sneaky
no reverence
for time and place
I learn to enjoy them
use them as
an excuse
to cuss those who are disrespectful
out
the women
in menopause
are awesome
fire power
no hose hookups
to put out
this heat and power
fat women have less *trouble*
with menopause
we stick together
like sets of bottled aged wines
our grapes grab our fingers and
twirl our hands
together.

Linda Keegan

RECESSION

It could happen at any time now,
the tooth fairies moonlighting,
doubling back to collect other parts
that my body is ready to discard.
Who do they think they are
fluttering through the darkness,
reaching under my pillow with cold hands?
What do they want now—
perhaps my breasts?
And what will they leave me this time?
Another quarter for a good one?
Nothing for decay? My god
how
do they get through the screens?

Emily Mehling

I, ODALISQUE

I, Odalisque,
je prends mon bain
to recordings of Horowitz
playing Chopin.
Notes fall in the water
like raindrops
or dragonfly eggs,
in the same order
that they were laid
or played.

This sloped medieval belly,
 Botticelli.

It's New Year's Day.
There's snow,
shallow as icing
on a cheap birthday cake.
Not that birthdays are ever cheap,
as earthdays go.
This year I've paid;
Rodin would know,
or show.

No fig leaf on me,
 Modigliani.

Je prends mon bain,
I, Odalisque,
reclining nude,
rude as any
Rubens brainstorm.
The notes
of the sonata form
mark me with brief circles,
transitory as coins,
or loins.

Dorothy Winslow Wright

WHEN DARK AND DAYLIGHT MESH

The creeping sunrise gilds the mountain ridge,
Dims the lights that etch the ocean road.
It shimmers in the glossy foliage
That cups the midnight wetness. Stars explode
In droplets tossed from fringing palms, fresh
In the breaking day. Black to gray to pink.
From pink to gold. As dark and daylight mesh
Shadows of the night begin to shrink.

What shapes those leering specters . . . breeds such dreams?
What spawns the tension festering in my mind . . .
Feeds the fear that breaks with silent screams?
Bathed in sweat, the panic undefined,
 I welcome dawn. As soothing colors rise,
 The polar worlds enact a compromise.

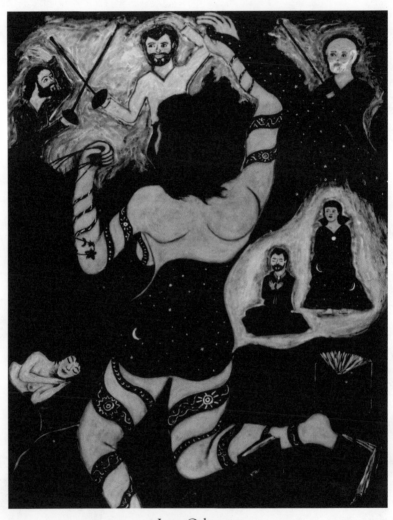

Jane Orleman

A DREAM OF UNITY: ALL FOR ONE AND ONE FOR ALL

II ▽ CLEARING THE PATH
Changing Relationships with
Friends, Family, Lovers, Others

Dannye Romine Powell

ALMOST FIFTY

Awake, I never think
of them. Dreaming,
they fill the ocean,
babies in coconut shells.
I wave from the shore.
They smile as they drift
toward me. I lift them cool
and nude from the water,
their sweet limbs all over me.

I wake to the ping
of acorns on the roof,
remember the summer
I was thirteen, rocking
the first baby I'd ever held.
That cheek against my face,
the head's soft bob,
the silent voweling at my ear.

Laure-Anne Bosselaar

MIGRATION IN RED

I bring in the geraniums, honey and pepper
trails of summer entangling my hair.
A season caught in terra-cotta. Tidy pots aligned—
a tiny parade—scents in a row on the window ledge.
It's time again. September's converging rows:
the geese's arrow pointing South, hummingbirds
hidden under their wings. From garden to narrow
sill, from sill to garden, I huddle another migration
against my breast, touch every flower,
breathe summer colors in every bloom.

A daughter flowers to love this coral opening,
a son reaches away, rises, proud corolla
springing from its stem. And here, my own life
arched: autumn angles a flower by the rim's edge.
I hesitate, then bring in the vulgar
hibiscus bought by a lover in midsummer's heat.
The garden is empty. All those reds inside!
Will they survive, reaching for the last lascivious
rays from behind the window's muslin:
sanguine fists—as mine—raised against winter?

Joan Lindgren

CHAIN LETTER

a daughter ripens under my eyes
nipples bud breasts swell
a waistline appears
a triangular cluster of curls

a womb begins to hollow a place for itself where
the center of a new universe will sprout
like dye in the veins of an x-ray patient
sap races and pulses
revealing itches and urges

I as observer learn to contemplate drought
a slackening of muscles' tone
an enigma of lines and blotches
a fraying of the fabric of libido

 the imminent obsolescence
 of equipment I seem to
 hardly have begun to use

Lynne Walker

NELLIE'S MENOPAUSE

I was a change-of-life baby.

Poor mother
didn't know about choice,
or hormones.

She didn't know
the side effects
of any of it.

As soon as her 8th child
was in school
she got pregnant with me.
Thrown into
post-partum blues and
menopausal mood swings.

My dad told me
she wanted to jump off the roof.

Diane Wakoski

MEDUSA ACCOMPANIED BY BARKING DOGS
IN THE CITY DUMP

I found you lying in the dump just outside of town,
your nylon hair standing like porcupine quills ready to shoot out
at the barking dogs.

Oh, what did they mean—
she had snakes for hair? What did they mean?
Cobras rising up to the full height of a man,
ready to strike? The python sliding down the tree trunk
over his head in a hiss of coils which suddenly
wrap a man's chest, constrict his breathing?

Your eyes do look surprised, I think.
You discarded doll, whom some little girl
 got for Christmas, probably once advertised on TV,
 wearing a dress of spangles, red, white and blue,
 like the one a sorceress wrapped around a princess
 to burn her to death for female treachery
your eyes so round, one half closed, as if to hide the fact
the other one might be a bullet hole.

They called the priestesses, who sat down in the crevices
of the earth at Delphi and smoked out their oracles,
"Pythoness," from the image of baby Apollo
his cherubic muscled miniature man-arms, wrestling
two snakes and killing them in his crib. You don't have
pythons or vipers like black whips for hair.
Only this stiff nylon, unbending when everything
else about you is melting and soft with age.

Why are women
only powerful when they are old
or discarded, when their doll eyes

are still slightly beautiful with paint
and they are missing the skin of youth?

Because they are no longer women?
Because they no longer bleed monthly?
Because at last they have been transformed?
their snakey power, so long coiled in the brain,
now shooting out of the head, into stiff tangles,
frozen like the locks of this doll?

Not even old yet,
 I've had my head shorn
in anticipation of what age brings.
I can't be Rapunzel,
though I still live
in the same tower,
and still look down at the Prince
who says he will
rescue me if I can just offer him
some way
to do it. My long hair, the coils of braid or brain
I once could have thrown down—I've cut them off myself.
Like the Medusa's snakey locks, they were starting to rise,
stiffening into the spikes of an iron fence.
Who wants to see an old woman with long hair?
Maybe it was once beautiful, though I never was.
Every time my name was mentioned
 "She's a real dog." / "She's a snake."
My hair glowed like moonlight.

Soft glinted strands of my shiny hair
fall to the floor every month now, as I am cut into an elegant
shape. If hair grows after you're dead,
I suppose I'll revert. Dig me up, and you'll see
Medusa, as many snakes as you'd find on an Indiana Jones movie set,
coiling and quarreling around my rotting face.

But now, though I know I am just like this doll
lying on the heap of refuse in the city dump, I'll hide
the snakes, the hair,
as well as I can. You don't need to look at it;
or worry about being turned to stone,
as you once might have had to.
I'll pretend I am still
a woman because I still feel like one;
but you're safe. You can look at me, without
mirror or sword.

Though why would you want to now?

THE MEMORY OF ALL THAT

I was scouring the bathroom sink when I thought of Mrs. Kratlian. I was surprised to have her appear in my mind, and trailing a mystery as well.

Mrs. Kratlian had been a neighbor on the street where I grew up. I doubt that I had thought of her since I was 13, which is when we got our first television set. The arrival of that machine broke our family's one link with the Kratlians. Fittingly, I suppose, television was the avenue which led my mind to Mrs. Kratlian again after 30 some years.

As I scrubbed the sink, I hummed Gershwin's "They Can't Take That Away From Me." I had first heard it from Fred Astaire in one of his Ginger Rogers movies. Fred had sung it to Ginger while they were riding on a ferryboat.

I saw that movie, "Shall We Dance?" and many others, about 20 times in my early teens thanks to a TV show out of New York called "Million Dollar Movie." "Million Dollar Movie" played one movie a week, airing it two or three times a day. My immersion in the romantic Hollywood products of the 30s and 40s may explain why I was a late bloomer. I never did learn how to lindy, fly, mashed potato, or Bristol stomp. I did manage to approximate the twist, but it took the Beatles to really propel me into a respectable adolescence.

Anyway, as I hummed Fred's song over the sink, my mind drifted to "Million Dollar Movie" and then to the years before.

The Kratlians owned the first television on the block. All the neighborhood kids would crowd in front of it to watch cartoons. Actually, it seemed to be the same cartoon over and over: a bewhiskered Farmer Brown or Farmer Gray with an upraised shovel fruitlessly and endlessly chasing mice. No dialogue. No color. Few background details. We were spellbound.

I remember the Kratlians' living room as always dark, probably because I was usually there at 4:00 or 5:00 on winter afternoons. The TV gave the only light. The two Kratlian boys, fat and swar-

thy and sullen, sat on the rug. The rest of us, still wearing our thick coats of forest green wool or brown corduroy, stood behind them. No one ever thought to sit on the plump navy blue horse-hair sofa or armchairs around us.

Mrs. Kratlian was a homely woman, short and round. She wore dark dresses that seemed shapeless even though they were belted and black lace-up shoes that I had seen only on nuns and very old ladies.

She was a housewife, like every other woman on the block, but she seemed truly wedded to her house. The other women could be seen coming and going, gardening, tending young children in yards, walking dogs. Mrs. Kratlian stayed inside. Waxy-leaved evergreen bushes obscured her front windows.

She came across the street and up on to our porch only twice that I remember. Once she was leading my brother home. His fore-head was bleeding profusely from a gash inflicted by a hoe swung by Mrs. Kratlian's younger son. The other time she was leading her older son, who had been bitten by our dog. Both times she was frowning.

I rinsed the sink and smiled over how the mind connects things. Then into my chiaroscuro memories of Mrs. Kratlian burst the bright pink belly-dancer's costume trimmed in gold.

My sixth-grade class had put on a tableau as part of a school assembly. At the center was the Statue of Liberty and grouped around her were eight or ten children in the native costumes of as many countries. I sat at Liberty's feet and represented Armenia in Mrs. Kratlian's belly-dancer's costume.

The costume consisted of sheer billowy pants gathered at the ankles, a closely fitting vest-like top cropped short, and a filmy veil long enough to be draped loosely and gracefully across the head, around the body, and over the lower part of the face. My teacher had insisted on the use of the veil. For modesty's sake I was to conceal my childish midriff and my non-existent cleavage.

I felt quite glamorous in the outfit, which was the most exotic and authentic of the lot. I knew I looked real.

The mechanics of how I was loaned this startling costume es-cape me now. My mother and Mrs. Kratlian were not friends. I never saw them together without a wounded boy between them.

I remember Mrs. Kratlian as gloomy and retiring. Yet from her had come the bold, resplendent costume. I imagine the shimmer-ing thing carefully wrapped up in some dark drawer in that dark

house waiting, almost with a life of its own, for an opportunity to emerge and be known again.

Perhaps Mrs. Kratlian wore the costume as a girl, before she was a Mrs. It is difficult to picture her belly-dancing, but I like the idea that she could have. Mrs. Kratlian, barefoot, is stepping rhythmically amid smiles and music. Her exertion and the firelight put a sheen on her skin. The costume, and probably Mrs. Kratlian, would have looked their best by firelight.

During one turn, the corner of her long veil slides across the knees of her future husband. The coarse weave of his pants catches at the lightweight pink cloth and for a moment the veil tarries, its edge brushing his lap with gold.

Or maybe Mrs. Kratlian had never used the costume, but only kept it because of who had passed it down to her. Perhaps a stern, silent grandmother handed it to her from a deathbed or perhaps it was left behind by a scandalous older sister after she ran away with her gypsy lover.

Mrs. Kratlian fingers the fabric of the abandoned garment and sighs. She spreads it out on a narrow bed. She has closed the bedroom door even though she is alone in the house. The costume, limp and quiet, still gives the impression of a woman's body. Mrs. Kratlian wonders about the memories of the women who have worn it.

Before storing it away, she sprinkles a fragrant layer of dried rose petals over it. She folds it slowly to hold them in. In ancient times, a rose hung over a council table indicated that everyone present was sworn to secrecy.

It often strikes me that the lives of women are suffused with secrets. How little, really, I knew of the lives of the women on that long-ago suburban street, lives that looked so straightforward and conventional. Or, how little I thought I knew before I was ambushed by memory.

Mrs. Kratlian walks to the kitchen doorway with an onion in one hand and a knife in the other. She looks across the dining room to the motionless backs of the children in front of the television set in the living room.

She stands watching them for a few minutes. They don't notice her. She knows if she approaches them they will jostle one another and lift their wide faces to greet her. If she squats down among them she will find their differences: the one with cherry

lifesavers on his breath; the one with a band-aid on her knee; the one with muddy mittens; the one with chapped lips and a piece of sleep in the corner of an eye. If she speaks to them, some of them will tell her stories.

But she stays where she is, and from her post the children, outlined by the light from the TV, appear to her as cardboard silouhettes, simple, static, obvious.

She returns to the cutting board and her own thoughts. Her memory lies in wait.

LUNCH WITH MY EX

He looks exactly the same
maybe a few more gray hairs.
He's wearing the tweed coat
I gave him one Christmas.

I stare across the table
remembering when I thought
if I bought a new nightgown,
dyed my hair, he might come back.

I know he will order
two spritzers and rice pudding
if it's on the menu
and that his mother's name will come up.

Everything else is different.
It would be easier to touch
the waiter's hands than his,
which once touched me all over.

I can see how we fit together
once, like two continents.

Now, looking at him
is like looking at a map
seeing in pastel colors
only the names of places
I once knew and loved.

I hear him talking. I'm remembering
how for fifteen years, the phoebes came back
every spring to our house in Vermont
to nest under the window frame

how each time, we were excited,
calling to each other like children,
"The phoebes are back! The phoebes are back!"
as they called *phoebe, phoebe*
their dark tails dipping with each cry.

I pick at my food.
Near the plate is a white paper.
"A quit claim to your part of the Vermont land,"
he's saying. "That's all.
Why are you staring?"

TUGGING ON THE LEASH

I'm tired of waiting
tired of writing personals

Attractive writer wants companionship
Too dull
Blonde poet eager for
Should read gray.
Woman writer who
takes off her underpants in the hall
has nothing in her icebox
but dog food and film
and sleeps under her books
seeks soulmate.
Too honest. Too long.

I'm tired of their answers, their photographs
the wrong men
in the wrong shoes
pictured by their cars
one fat one hanging from a parachute
over Acapulco
for God's sake

I'm tired of being coy
when my body's not
ticking down its checkups
like my car
ovaries that don't make ova
eyes that can't read maps
a stomach getting bigger on bean sprouts
better to wear out than to rust out.

I'd like to be more like my dog
when out the door we go
sniff sniff wag wag
even without seeing a female
he licks her scent
on the sidewalks, on the hydrants,
smells her on the bushes,
shakes uncontrollably and drools.
And when he sees her in the fur-flesh
he wags and sniffs her crotch.

I'd like to be more like him
and why aren't I?
He's the one, supposedly,
who doesn't know
his time is running out.
I'm 50 and horny and lonely
and like the fall leaf
still in the tree
there's gold in me left.
I know you're out there.
Hurry.

C.K. Freeperson

EYES WITH NO AGE

I liked
his
eyes
but me
45
hot flashing
he riding his moto guzzi
I envied
his motorcycle
as he
flung his leg
over one side
of it
I liked the way
he straddled
it
and hot flashes
as red and warm
as his directional
signals
we kept time to
the flashing stop lights
outside the studio
windows.

EVEN NOW

even now
with gray temples
your eyes
still hold me
there in them
we twinkle
as
young lovers
now
we are
aged
like good pasta sauce
or
good movies/songs/classics
menopause
we
hold
its hand and
ride the roller coasters
hormones to orgasm
just
as
if not better
than when we were girls
and first
in love.

GRAMMA AND LOVE

Snow covers
her head
she said
with white hair
I can get away with anything
a 19 year old lover
male or
female
love at 48
is a craft
well honed
spiritual
disciplined
and
sacred
although society
devalues us
it takes us home to its older woman's
breasts
upon which we lie
without contempt
lie as if on our own
no derision
holding ourselves
together

SEQUINS

Sandra's eyes opened. The clock said 6:30 AM. In her dream she had been standing on a stage before a large hazy audience, performing something in a huge theater. Was it a poem? Was she in a play or singing a song? Then she remembered, still within the dream, that she was dreaming. She was not a performer, not an actress, singer or poet. She was a teacher and department head at Monterey City College. She was a wife and mother. And she began to sob, still within the dream. She woke up startled, as she always did from an episode of this dream, surprised by the absence of real tears in her eyes and on her pillow.

Cool late fall sunshine entered through the curtains, bringing life to the nature photographs on the bedroom wall. The eyes of the arctic wolf glistened. She was touched by its directness and vulnerability. It had escaped domestication. Stephen, her husband of twenty-five years, lay snoring next to her, the cream colored sheets pulled up to his nose, vibrating as he sensed the change in her movements. He groaned, turning on his side to face her, putting an arm around her to "spoon." She turned on her side, snuggling in for a moment, feeling his body form a mold against hers. She closed her eyes, feeling a comfort that rarely failed.

It was Thursday, three days before her fifty-first birthday and a huge party was planned for Saturday night. Stephen wanted to do the party last year, but she hadn't felt like celebrating. He relented only after she promised he could do it this year. Now he had rented a hall, hired a band and caterers, and taken half the week off work to coordinate the details. Her parents were flying in from Arizona, her brother and his wife from Los Angeles and their daughter, Kirstin, from Boston, where she attended university.

Sandra felt a churning wildness in her belly that came up through her chest. It knocked against her, trying to escape. It certainly was not going to let her go back to sleep. "I've got to get out of here!" it said, propelling her out of bed. At times like this Sandra

wished she were an athlete. She imagined that skiing down a slope at 30 miles an hour or the hard competition of a tennis tournament would take the edge off. But skiing terrified her and competition made her crazy.

She got out of bed, glad Stephen was still asleep. She didn't want conversation; she wanted to "get the hell out," she said aloud, throwing on her terry cloth robe and shivering toward the bathroom.

After her shower, she packed a small suitcase, asking herself, "What on earth am I doing?" But no one answered and the wildness hummed steadily. She tossed disjointed items in the suitcase without any idea of where she was going or what to pack: her fanciest dangling rhinestone earrings, bathing suit, black high heeled shoes, running sneakers, her favorite sweater, purple and green, oversized and hand knit, hose, make-up, some old comfy and some new elegant underwear. She noticed herself sweating as she ran out the door that led to the garage, jumped in her car and headed north. She had never in her twenty-five years of marriage left the house with the intention of staying somewhere overnight without first talking it over with Stephen. But now, here she was driving God knows where. She put an oldies tape in the stereo and rolled down the window, feeling the ocean breeze.

Aretha was singing "Natural Woman" when Sandra pulled the car off the highway onto a lookout. She sang along, the music rising from her belly. When the song ended, she sang it again, herself. "I could have been a singer," she said. "I know I could have." She got out of the car and climbed down a rocky incline that led to a secluded beach, realizing, as she descended, she had been on this beach before, many years ago.

Sitting on the soft fine sand, looking at the vast blue water, "I want to be you," she said out loud. She could feel the desire in her chest. "I want to be the ocean and the sand and I want to be you," she said to the pelicans, feeling the expanse of their wings, the air currents against her, the synchronism of their flight. "I want to fly south with you. Don't leave me." She looked at the waves, feeling their fierce power. "I want you, Johnny. I want you so much." She felt his body, warmed from the sun and from her own sun warmed body. They were lying on a blue worn cotton bedspread in their bathing suits, their legs wrapped around each other. They kissed the deep kisses of first love, like tasting magic fruit, and stared into each other's eyes, in a daze of passion. They held each other's face

and felt the full force of wanting. "I want you Johnny. I want you so much. I'll never want anyone the way I want you." His chest felt so good against hers. His taste, his smell... She wanted to roll into him, to become him.

She was a senior in high school when she met Johnny Sanchez. She thought he was the handsomest guy she'd ever seen. Their connection was immediate; they began dating the night they met.

They were unprepared for the depth of their feelings and confused by the conflict generated in their families. When Sandy became pregnant, her mother arranged an illegal abortion in Los Angeles. That was the end of her relationship with Johnny and his Catholic family. For two years, Sandy's heart felt so heavy she could barely move. She put off starting college, and lay in bed crying.

She met Stephen Miller three years later. He was gentle, funny, smart, even-tempered. They both loved music and dancing. His love for her felt like a balm to her mending heart. They married a year after they met. Their passion quickly turned comfortable and cozy.

Giving birth to Kirsten lifted a weight from her heart. She doted on her daughter, although now and then an image of the child and life she never had would float through her.

Her year with Johnny was the only time in her life she did exactly what she wanted, driven by her own passion. After the break-up, she gave up her effort to become a singer or actress. She was vulnerable to her parents' insistence that it was impractical. "I did it to myself," she said to the waves, as she stood up and began her climb, "and I'm not going to do it anymore."

Back in the car, she once again felt the wildness she awakened with, gurgling and humming in her middle. It compelled her to continue.

Then the ocean disappeared and Sandra continued heading north on highway 101 and then 280. "I guess I'm going to San Francisco. Why not?" She was hungry and exited at 19th Avenue, pulling into Stonestown Shopping Center, thinking she would eat, buy herself a little birthday present, and call Stephen so he wouldn't worry.

She entered Nordstrom. An emerald green silk sequined dress caught her eye. It was beautiful and slinky, long sleeved with a slim skirt, slit up both sides to the thigh. As she stood admiring it, a saleswoman approached her. "That would look beautiful on you, with your red hair. Would you like to try it on?" She nodded.

Looking at herself in the mirror, she ran her fingers through

her wild curly hair. "I am still a pretty woman," and she hummed "Happy Birthday," viewing herself from different angles. She smiled as she purchased the dress.

She called home from the coffee shop, glad to get the machine. She told Stephen not to worry, she needed some time alone and would probably return tomorrow night. Then she called the Inn on Union Street and reserved a room.

As she finished her lunch she admitted how out of sorts she had been feeling. She was tired of dealing with students, Stephen's little quirks annoyed her, she felt bored talking to her women friends; even her daughter's calls from college were irritating lately. She felt as if her skin no longer fit properly.

Stopping her thoughts, she headed toward the store exit, passing the make-up department. She approached an attractive saleswoman whose coloring was similar to her own. "I'm going to a very special occasion, my fifty-first birthday party," Sandra heard herself saying. "I'm wearing this dress," she lifted the bag and showed it to her. "How about making me up?"

"That dress is gorgeous. I hope I look half as good as you do when I'm fifty-one," she said, motioning toward the chair.

Conservative with her make-up, Sandra was shocked when she looked at her image in the mirror. She looked like a stranger to herself, a gorgeous stranger. "You are an artist!" she told the woman.

Back in the car, heading toward Union Street, "What am I doing," she wondered. "You're only fifty-one once," she answered. "Where is this taking me?" "You'll see," she replied. She felt a little silly in her jeans with all that make-up. She kept glancing in the mirror and feeling gorgeous as she dramatically made pouty kissing gestures to herself. Every so often a whisper of a voice would tell her to turn around and go home, but it was weak and she could drown it out by singing or cranking up the music.

She arrived at the inn and checked into a lovely room that opened onto a little garden. She sat outside, staring at the clouds for a time. Then she unpacked and took a long hot bath, being careful not to mess her make-up. She lay down on the bed, just drifting in her thoughts, half asleep, feeling luxurious. At nine o'clock she slipped into her evening dress, touched up her make-up and called a cab. She asked the driver, a young pale man with a punk haircut, to recommend a small club with good rhythm and blues, and atmosphere. He took her to a place called Roxie's—dimly lit, small tables, somewhat crowded. A sax player was doing a solo. She sat

at a small table to the right of the stage, and ordered a brandy.

When the band took a break, she followed them backstage. She approached the leader, an attractive, middle aged black man. "I liked your music," she said looking deeply into his eyes.

"I like your music, too," he said.

"My name is Sandra," she extended her hand.

"I'm Thomas," he said, taking her hand and holding it for a moment. "And you look very beautiful in that dress." He was looking at her appreciatively.

"Thank you, Thomas. Tomorrow is my birthday and I would like to sing a song with your band tonight, to celebrate. It's..." she hesitated, "important to me. Will you let me do it?" Again, she looked deeply into his dark eyes. "I want to sing..." she paused, "'Since I Fell For You.'"

"On one condition," he said.

"Name it."

"That you let me take you out for a birthday drink later."

"If you add some food, you have yourself a deal, Thomas." She turned and walked back to her seat and sipped her drink.

Thomas started the second set with "When A Man Loves A Woman." He sang it well. When he was finished and the applause stopped he said, "We have a special guest here tonight, Ms. Sandra..." he paused. He hadn't asked her last name. "Ms. Sandra Franklin, a singer I first met when I played a club in San Diego several years ago. She has agreed to do a number for us."

She walked slowly onto the stage, and whispered to the band to let her sing the introduction alone. She turned and faced the audience. The spotlight made her dress sparkle. "I'm very happy to be here. This is a very special night for me. I dedicate this song to all of you and to Thomas."

She took the microphone off the stand and began to sing.

"When you just give love and you don't get love,
you'd better let love depart. I know it's so and
yet I know, I can't get you out of my heart..."

Her voice was strong and soft and full of feeling. She sang about every time her heart had been bruised. She sang about what it meant to be fifty-one years old and to have no control over the time rushing by. She sang from her heart. And the audience knew. They were silent and they knew. When she was finished, after a pause, they applauded loudly.

"Thank you," she said, "Thank you very much."

Anne Marple

THE HUNGRY WIDOW

Sex ceases to be spontaneous
in this age of AIDS,
but there are compensations,
and time to prepare—
and you need it if you've
been sharing your bedroom
with an incontinent cat as I have
and you're almost sixty-five,
and don't lubricate as you once did,
and the handsome-hunk house painter—
who's fifty at the most,
and the object of masturbatory
fantasies all spring—
drops in to tell me
he'd seen my breasts one morning
when my peignoir gaped and he wants me,
but his brother's in the car,
so he'd like to make love to me Saturday.
I would like that, too, I say.
After a few tentative kisses and gropings
that don't live up to my fantasies
he goes away and I start preparing.

I went to the pet store and bought
a deoderizer for cat urine
and shampooed my rug.

I went to the pharmacy where I'm not known
and asked in a frosty voice
for a recommended lubricant named Astral-glide.
"Astro-glide," corrected the gentle giant

who held out the two available sizes.
I pretended to read the labels
and took the large economy size
although a drop would do.

I carried tons of papers out of my bedroom
and stacked them on the guest room bed
re-lined my bedroom drapes
with a paperclip-hung, king-sized sheet
that would shed a kindlier light on the scene.

On Friday morning I went to the market,
bought flowers, cantaloupe, Persian melon,
raspberries, strawberries, and peaches.
In case he wanted Belgian waffles
I added pecans, whipped cream,
sweet butter, and lingonberry jam.
I went to the best Swiss bakery and bought
fresh croissants and a coffee cake called Paradise.

Friday afternoon I went to a beauty salon
and had a facial, a manicure, and a pedicure,
a shampoo and a set designed to hold up in bed.

Humming "Pretty Woman" all the way to get up the nerve,
I went into another pharmacy where I was unknown
to ask the pharmacist for an assortment
of his best condoms.
A stuffy pedant, he said there was no such thing.
He said it all depended—
did I want to prevent pregnancy or disease?
I told him I thought at my age
we could focus on the latter
so I bought two packages laden with spermicide
just in case my painter forgot.

Last of all I set up a patio chair on my balcony,
convenient for a post-coital cigarette
and went to bed early to be ready for morning—
the scent of night blooming stock in my nostrils—
my puzzled cat curled at my feet.

Jean Esteve

THE SWAMP

1.

Uh-oh, Mother.
I think I've got it.
You know—what you told me.
Icks. It's sticky.
You didn't say that.
I sure hope
there's more than this
to being grown up.

2.

He put his arm around me
in the movie.
Later, we sat in my porch.
He kissed me on my mouth,
and sort of slid down to my chin,
and my neck,
then he got a hand inside my coat,
and up my sweater, you know?
and his finger flicked my nipple,
and his tongue went in my ear,
and all of a sudden—
oh, god, I was so embarrassed—
I wet my pants.
You go home! I told him,
so he left and I got up
to go to the bathroom
and it wasn't exactly pee,
it was kind of—
It was?
I did?
Hot damn!

3.

For weekend amusement
we stew in our juices
and strew our pajamas
and snarl the linen
And then it's for coffee
and fried eggs and laundry
and gluey dishes and douches.

4.

Baby
Oh, baby
Oh, baby, come
now, baby, come
Oh, baby oh, baby
I can feel it
I can feel it
Easy now
Come now
Oh, now—OW! OH!
Baby
Oh
Baby
Come baby come baby
N-O-W.
Sweetheart
Little gummy dear
You are just who I hoped
you'd be. I'll name you Noah.

5.

As I walk to the store
over by where they drained the swamp,
my legs rasp against each other,
parched, like two beached sharks.
I buy one bloody chop,
a quarter pound of yellow squash,
a Santa Rosa plum.
And I wear no underwear.

Gloria Vando

IN THE CREVICES OF NIGHT

There's a man in my dream
a man with a hatchet
ransacking my bureau
hacking at the doll asleep
in the bottom drawer.

A bloodless ritual.

He calls himself a surgeon, says
he's up on the latest laser beam
techniques. I know better.
I know the jig's up.
Youth is waning and the end
is closing in on the beginning—
a telescopic fantasy focused
on dismembered limbs, a glass eye
rolling across the parquet floor,
tiny fingernails scattered
in my underwear scratching
at the obscenity of early death.
But not a drop of blood. Not a cry.

I turn from the dream, reaching
for you across the thin ice of night
and pressing my body to yours
long, foolishly, to bear your child.

Judith Bishop

MENOPAUSE

I.

This blood
ties and unties
through every tissue.
I see it in your older temple
and I feel it up my arm
as you describe meridians
like a chart of arteries.
This point to this point to this.
I count days like stitches between periods
now that they soon will stop.

Ah damn that little death.
The thread of blood
will tie itself into knots
as I twist the sheets
dreaming I have been condemned.
Awake, I see when I was fourteen
much farther away.
This change
pulls all change with it.

The engine stops its throbbing out at sea.
The torso shudders as though with flu,
breasts hot and sore
as though more were coming
but nothing comes.
The thermostat is off
and I overheat like a stalled car.

II.

There is traffic in the trees,
susurrus of boughs on the mountain.
My attention draws down
—the low branches old and silver—
to a perfect drypoint of the vascular system.
I stand before it as at a museum,
cool, analyzing its form
until a small animal I can't see
whimpers like a bird.

This pulling in
knits me deeper into life,
shrinking me
until I'm dense as felt
with the intelligence of the physical.
If I can come to death
folded into the longer cycle!

Tonight, up between the sugar pines,
the constellation
that is wisdom, the archer,
draws the bow that is our blood,
perception
propelling us into the stars.

III.

We go nowhere without ourselves,
without limbs and breath, muscle
and menstrual cycle. Not even to the moon.
Too often I try to be detached,
thinking that thought is impersonal,
impatient with the push of hormones.
Then I am no better than the engineer
who thinks his way to missiles,
the murderer intellectual.

We go nowhere without ourselves
and therefore without each other.
My husband and daughter invented a game
played on a board like chess
for long evenings in winter
when the trees cracked at zero.
To win you had to bring
your adversary with you,
get out of the cold together.

But that marriage has broken,
and most ties to lovers, friends.
I am a terrible example, a solitary.
I listen to the river at night
at the end of the meadow
as though the moon in the shallows
were my only familiar.
Blood ties me to her,
my daughter, the onslaught of winter.

Marion Cohen

THIS TIME OF LIFE

When Devin at five sleeps with Bret or Aurelio,
he sleeps till dawn, and awakens,
springing for Apple Jacks, Nintendo and hikes to Fairmont Park.
But when he sleeps with me he forgets that he talks,
forgets that he walks
forgets that he grew—or maybe just dreams he didn't.
Then, it's before dawn he surfaces, before dawn he reaches.
"Mommy," he says, just, "Mommy," and he crawls over
and roots just like a newborn, those same mini-munches,
and quite soon tapering, as sleep washes over him,
as sleep and comfort roll him over.

And he doesn't seem to notice how much smaller I've become.
How his toes are at my knees, his hair at my chin,
how his arms have to fold in order for his fingers
to hold one another.
He doesn't seem to care how I've shrunk, withered,
how I am *late* 40s now,
and that my blood is tiny, invisible, how my months are missing,
no more schlishy-schloshy;
doesn't seem to mind that I'm disappearing,
becoming a *little* mother, a *far* mother,
as far as my own mother—
doesn't seem to notice all these dark things.

Arlene L. Mandell

HOLDING ABRAHAM

Abraham's skin is as smooth a suede.
 His ears stick out. His plump arms
 and legs swim through the air.

He snacks at his mother's breast,
 dozes off, then wakes to gurgle
 and swim again.

He protests when I take him
 from my daughter so she too
 can eat dinner.

I turn him on his stomach. he rests
 his mouth on my bare arm, suckles
 against my skin, content for now.

Silly little boy, doesn't he know
 I have no milk for him, that my
 childbearing years have ended?

He cries again for his mother.
 I hand him back, still feel
 his mouth pressed against me.

CLEARING THE PATH

My husband gave up shovelling snow at forty-five because, he claimed, that's when heart attacks begin.

Since it snowed regardless, I—mere forty—took the shovel, and dug. Now fifty, still it falls on me to clean the walk.

He's gone to warmer climes and younger loves, who will, I guess, keep shovelling for him.

In other seasons here, I sweep plum petals or magnolia cones to clear the way for heartier loves.

Tonight, New Year's Eve, my failing father asks if it's true I am pregnant. I shake my head, but he can't see.

One blue-flowered gingham dove dropped from the Christmas tree reminds me I'm no more a stuffed duck. Rather, a sailor granted liberty in Rio, the only admonition being, remember golashes. Otherwise, no clock or calendar or globe tells me where I am or ought to be.

Gold-rimmed and chipped dishes sit in the fetid sink with garlic peels and feta crumbs. The swelling black and white cat licks my wrist as if I shared in her complicity.

ANNUNCIATIONS, OCTOBER

As she waits, she gathers tomatoes,
eggs from the snowy hens,

plums from the seed
she planted at seventeen.

The sea smells of flounder and crab.
Her house smells of basil and yeast.

Spiders have woven together
the corners of rooms,

katydids whirr emerald songs,
crickets sing in the cracks.

The younger man comes down the road
with a basket of peaches and wine.

One string hangs from her mandolin:
he winds it around the peg.

They cross the yard. Leaves spiral,
catch on zinnias, jimson weed.

He bails the old boat in the sand
with the shell of a horseshoe crab.

High tide. They sail from the cove
ignoring the squall and rising bilge.

All day his eyes speak
of desire and regret.

All night in the waves
she dreams: after years

a bright rush of blood,
new songs on the mandolin.

Sondra Zeidenstein

THE ONE DREAM (A SPELL)
for George

Over this long-married pair, sprinkle nepenthe.
Let them forget for an hour on Sunday
 Afghanistan, Palestinian camps, a child's face
 crumpling under a threat.
Clear the airwaves honeycombed with sorrow.

Let the sun flash through maple flowers tasseled
 like earrings, through small-paned windows,
 touch their peach duvet, peach flannel sheets.

Let karmas of cramped children, stunted parents
 give room.
Shut the sad brain, let it be skin only.
Draw a circle around their cherrywood bed for this hour.

Let the rich glow of the cave burnish away
 their imperfections.
Let their eyes be slits, discriminating.
Let hands soften, hips unknot, backs let go
 old compressions.
Let failures spice their soft bellies, their tinder
 take fire.

Let them not be young, betraying each other, oh, not
 young.

Let them touch each other's eyes smiling.
Let words move sweetly in their saliva.
Let her breasts be richly complicated.
Let his penis rise wise and humble.
Let him seek her in his fingertips.
Let her moisten a tangy nectar.
Let them be careless, slippery, forgiving.

Let their cries enter brooks rushing the gorge,
 ring in the calls of Canada geese,
 red-eyed vireo, raccoon.
Let that safe room spread its held heat into the world.
And let them naked, entwined, sleep,
 dreaming like Vishnu
 the one dream.

Jane Orleman

EVER AFTER

III ▽ THE GOOD, THE BAD AND THE LUDICROUS

Medical Interventions

Wendy Wilder Larsen

MY PLACE

No place for life
a home for tumors
they scooped me out
like a melon
scraped to the rind
leaving me to sleep
with the moon
a white dog
and a scar to fence off the area.

I envy the killdeer chick
born on the parking lot floor
safe without a nest.
At the least sign of danger
its mother leaps into the air
squawks, feigns wounds
sidesteps with drooping wings
displays her speckled chest.

Dropped on granite
wild heather doesn't know its mother.
From blood red stalks
its white bellflowers swell.
I'm named for Queen Cassiope.
I suck beauty from stone.
Neither wind nor cold can shut me down.
I bloom above the timberline.

THE TRANSFORMATION

"But if she gives you a hard time about it, ask her what she proposes to do if the uterus ruptures," said Dr. Turner.

The shock of this statement hit my uterus and proceeded downward to my toes.

I'd been trying for eight years to get rid of that uterus. Every time I went back to Turner and said, "Look, I'm bleeding to death every month and I want it stopped—I don't need that uterus any more," she would look at me with the calm, evaluating gaze she always used when I said something outrageous. "Scotland is not America," she would point out. "We don't do hysterectomies on demand here. We believe in the conservative approach. At your age you won't find a gynecological surgeon who will remove your uterus, unless its condition is life-threatening."

"What do you mean at my age for Chrissakes? I'm forty! I've got two children. I don't want any more. I want to be rid of this."

"But just think, if you lost a child you might want another one and you wouldn't be able to have it."

"If both of mine fell under a bus I should be desperately unhappy, but I would not have another child. It was too much of a hassle having the ones I have. I've done my reproductive bit."

We went over this same ground about once a year thereafter, and I always lost. Turner would never refer me for surgery.

But I was bled white due to the fibroids which had collected over the years in my womb. These increase the womb's inner surface many fold, producing a large area of cyclically developing tissue which breaks down into an excessive menstrual flow. I became so bloodless that my immune system was almost non-existent, and I caught every bug going around. I was always ill, but couldn't go to bed as I had a full-time job of teaching and research plus two kids and a home to cope with. Instead of the surgery I needed, Turner prescribed librium to elevate my mood and sleeping pills to make me rest. Depression was my problem, she said, not my uterus.

After eight years of fruitless argument, I went to her for what I

thought was something else. Pain in my lower left abdomen. I thought it was gut. Turner poked and probed, and I said "Ouch!"

"That's uterus," said Turner. "You really don't need it any more. I'll refer you to Mary Chandler at once."

"At last!" I commented pointedly.

"Mary Chandler is the best. I wouldn't send you to just anyone. But she may not want to do it. She's very conservative. But if she gives you a hard time about it, ask her what she proposes to do if the uterus ruptures."

I was both elated and scared stiff. What if they didn't get it out in time? My immune system was in no condition to fight peritonitis.

Mary Chandler saw me the same day. She poked and probed, and I said "Ouch!"

"You don't need that uterus any more, Mrs. Williams," she said. "We'll get it out. I've a slot on Friday if you can arrange to be in hospital by noon on Thursday."

I was glad it was to be so soon. I just wanted to get it over with. I'd been sliced from belly button to pubic bone twice before—caesarian sections the old-fashioned Scottish way—and knew the third slicing would be no more pleasant.

On Thursday the hospital vampires took away what little blood I had left for tests. Friday at 11:00 a.m., ravenous and hypoglycemic from having no breakfast, and hypomanic from the premedication they'd administered too early, I was wheeled off to the operating theater.

I awoke back in the ward. I was wired up to a transfusion drip and my urethra was plugged with a catheter which drained into a plastic sack at the side of the bed. I was numb all over but knew it wouldn't be long before the medication wore off and the fun would begin. I glanced at the ward clock, but the numbers swam like snakes and I couldn't read them. "What time is it?" I asked a body who was passing the bed. "Nine p.m.," it said. Christ I'd been out cold since 11 a.m. Ten hours! What had gone wrong?

I drifted in and out of consciousness and was roused perhaps half an hour later when Mary Chandler appeared at my bedside and spoke to me.

"It wasn't an easy hysterectomy, Mrs. Williams," she said. "You had so much scar tissue and adhesions from your two caesarians that we could hardly find the uterus. Adhesions are highly vascularized, as you know, and you lost a lot of blood. You're on

your second transfusion now. In getting the uterus out we nicked the bladder wall and had to sew it up, so you'll need the catheter to keep the bladder from filling until the nick heals."

I was too weak to comment on this tale of woe. Instead I asked if she'd left my ovaries in.

"No. They were full of cysts and would very likely have soon given trouble. I didn't ever want to have to open you up again, so I took them out."

Having been told for years that ovaries were left in at hysterectomy when possible to guard against premature aging and osteoporosis, this did not please me, but I could see her point.

That night I slept fitfully, waking each time the night nurse came to check on the transfusion drip. I dreamed I was floating on my back in a deep pool of black water, in total darkness save for the light of stars overhead. When I awoke I found I was floating in a sea of sweat, sheets and nightgown drenched. I'd had my first hot flash from estrogen withdrawal.

Recovery was slow, complicated of course by the inevitable urinary infections rampant in Scottish hospitals at that time. I was mentally shattered by whatever they had given me in the spinal anesthetic. My head wasn't screwed on straight for at least two months. They kept me in the hospital sixteen days until the catheter came out. Then my husband and children picked me up and drove me home. My depth perception was still so kaput that I kept thinking we were about to crash into passing cars and lamp posts. It was a week before I was strong enough to walk across the narrow road in front of our gate and sit on a bench in the park.

In spite of these surgical aftermaths, as soon as I got home I began to feel life flooding back in a way I hadn't known it for years. I felt waves of something that whispered "rejuvenation."

My mood had for years been mildly depressed, with strong monthly down swings into the cellar and below. Now, I noted, I was mildly elated with occasional highs verging on the manic. When the time came that I would normally have had my monthly death bleed, I became so elated at its absence that I could hardly keep from rising up and floating off.

I phoned up my friend Sylvia: "Come on over here, I've got a present for you—a cupboard full of Kotex and Tampax you can have with my blessing. I'll never need it again! Whee! You can even have my diaphragm and spermicide. Guaranteed effective!"

Another friend came by about a week after I was out of the hospital and found me soaking up sun in our snugly enclosed front garden. She came in with a long face. "You poor dear, how are you? Are you terribly depressed?"

I looked at her as if she'd lost her mind. "Hell no," I said. "I'm manic. Still weak, but I haven't felt this good since I was a kid."

She looked disappointed. I'd shattered a stereotype. Current wisdom had it that after hysterectomy women were severely depressed because youth, reproductive capacity and sex life were over. They were put on tranquilizers to calm their nerves, sleeping pills to keep them quiet at night, synthetic hormones to stop hot flashes, and antidepressants because the husband would be off looking for a new young wife.

My experience was totally opposite. I awoke the first few nights after surgery in a pond of sweat, but these hot flashes rapidly became less intense and I never went on hormone therapy. My skin did not fall into a mass of wrinkles, nor did it sprout superfluous hair. Now that I was no longer chronically losing blood, my zest for life in general and sex in particular went shooting up. I came off tranquilizers and sleeping pills and never went back on.

From the beginning, my ovary-free life was a revelation to me. I was delighted with it. I had not realized to what extent my former life, and my personality, had been influenced by fluctuations in ovarian hormones. Now I felt as I remembered feeling before puberty: full of well-being, upbeat, embued with boundless energy and joy of living. In other words NORMAL. A healthy human being. No more shattered nerves because of pre-menstrual tension, brain no longer frazzled into incompetence. Just ordinary, alert responsiveness to my environment, and a new-found ability to refrain from screaming at my kids. The decrease in sex drive after day 21 of the menstrual cycle was no longer evident. I was ready any time. People still took me for ten years younger than my age. My husband did not decamp for a younger woman as predicted, despite his chronologically passing through the time of expected "male menopause."

My hysterectomy was fifteen years ago. I have remained in excellent health, and with my usual habits of exercise and a sensible diet I intend to keep that way. My only problem is self-induced: fatigue caused by trying my manic best to crowd 48 hours worth of activity into 24.

Lynne Walker

FOR BRENDA STAR

The doctor prescribed
estrogen and progesterone.
I can take them
as long as I want to
stay young.
I feel good—like
May West in combat boots,
Mona Lisa with eyebrows,
an over-sexed Squeaky Fromm.

I'm Nadine without eye patch,
Sinead O'Connor with hair,
Madonna without sharp edges,
I feel sexy as Marilyn looked.

My babydolls are starched,
I've got my running shoes on.
I'm a cheerleader without a cheer,
just wanta bounce you around, baby.

I'm comin' ta get ya!

Ingrid Reti

THE CHOICE

> "Estrogens have been reported to increase
> the risk of endometrial carcinoma."
> —Premarin™ patient insert

To take estrogen, or not to take estrogen:
that is the question: whether 'tis wiser
for the mind to conjure the dangers of ingestion,
or to take estrogen for post-menopausal syndrome
and by so doing cure it?

 To choose: to wait in fear; and
by my choice to know I picked the future
my flesh is bound for, 'tis a decision to
be pondered greatly.

 Thus choice, coupled with
the pale cast of thought breeds ambivalence and
stifles action in us all.

Elisabeth Holm

ESCAPING ETERNAL COMPULSORY FEMININITY:
THE ESTROGEN DECISION

I was raised to honor and obey the medical establishment, which I was taught represented irreproachable authority and a source of protection against all physiological peril. In my early twenties, a fresh graduate in Foods and Nutrition from Iowa State, I took the first of many hospital jobs as a dietician at Columbia Presbyterian in New York City. In my mid-twenties, I married an M.D. who had just completed his ophthalmology residency at a nearby VA hospital. We soon moved upstate, where he established two practices and I bore four sons.

During my thirties, while I was submerged in marriage and mothering, I was peripherally aware that my own mother was passing through menopause, and was taking Premarin, sure that it was the best thing for her. But I had not formed any opinion myself about the advisability of Estrogen Replacement Therapy (ERT), not considering it relevant to my own life at the time.

In my early fifties—after I had divorced the doctor, raised the sons by myself, done a Master's degree in literature, put all four sons through college, moved from New York to California, and then to Oregon to return to graduate school for a Ph.D.—the issue did become relevant, and I had to decide whether or not to embrace ERT for myself.

While I was working on my doctorate, the indignity of being a student at such an advanced age was compensated in a surprising way: at the Student Health Center, I found a wonderful young female physician who was thorough enough to take an interest in my inherited hypercholesterolism, and sensible enough to respect my maturity. Moreover, she validated my growing conservatism about taking drugs of any kind.

Nevertheless, she did present me with the presumed advantages of taking estrogen in order to reduce the risk of post-menopausal osteoporosis, and to manage cardiovascular health, i.e., to avoid an early heart attack like the one that had killed my father. But

when I expressed concern about estrogen therapy being implicated in increasing the risk of certain kinds of cancer, she listened to what I had to say. Her response, based on her reading of the then available literature regarding taking progesterone to oppose estrogen, was to recommend that I take estrogen for the first three weeks of my cycle, and progesterone the fourth. She assured me that, on the one hand, the combination of the two hormones would help to reduce the threat of cancer but, on the other, it would continue to generate menstrual cycles for as long as I continued the therapy.

I briefly envisioned the grotesquery of being eighty and still bleeding every month, but I was charmed by the prospect of escaping from the hot flashes that had been troubling me. I decided to give it a try and, sure enough, the hot flashes were diminished. However, the relief of their abatement was offset by a menstrual cycle which was extremely erratic: some periods were heavier than normal, some lighter, and their onset was not exactly clockwork, so my enthusiasm for the intervention was far from whole-hearted. Moreover, during that trial period there were two events that impressed me enough to shape the decision to which I have now come regarding ERT.

ONE: I walked into the largest ballroom of the local luxury hotel for an informational meeting on ERT, which had been promoted by the largest local hospital in town, and found myself in a sea of at least a thousand women, most of them in their forties, and neatly dressed. The crowd seemed to hum with anticipation. The speakers presented what appeared to be a level view of the advisability of the therapy, but their position and motivation were eminently clear. The current evidence of increased likelihood of breast or cervical cancer was, they assured us, equivocal. The therapy would help us. Our quality of life could be greatly enhanced.

More than the words from the podium, however, the very scene in that ballroom was illuminating. If most of those women bought one pill a day for the rest of their lives as the presenters recommended, someone would stand to make a fortune! It was not surprising then that they could afford to provide ice water and free coffee.

TWO: I was in the well-appointed exam room of a bright young orthopedic physician who had been following my chronic lumbar spine problem, and had always sprinted out of each forty-dollar

encounter, sometimes shaving the total time to about forty-five seconds. I was inspired that day to get a bit more for my money, so I asked for his opinion regarding the advisability of ERT. His answer was rehearsed and succinct and emphatic: If I got breast cancer "they" could take off my breast; and if I got cervical cancer "they" could take out my uterus, but if I got osteoporosis and broke my hip, "they" couldn't help me. ERT was the way to go. And he was out the door.

It wasn't until I got to the parking lot that I noticed the reductionism of the very structure of his recommendation: The subject of both parts of the compound sentence had been the collective surgeon, while I had been consigned to the dependent clauses. Furthermore, I had mentally sustained the horror of having my breast sliced off, and my womb carved out. Those few flat words had left me feeling distinctly diminished, and were quite frankly cause for revolt!

Shortly thereafter, I stopped taking the pills.

After long and careful deliberation, I realized that I can care for my bones better than "they" can. Not only as an ex-dietician, but as an intelligent woman, I know how to get enough calcium, and I can consistently get all the weight-bearing exercise that I need. I can also create cancer deterrence by avoiding stress and saturated fat. In fact, I find that I prefer the security of my own active caring for my health over any passive reliance on medical intervention.

Since that time, I have come to recognize that my decision to stop ERT came not just from practical considerations, but from a constantly evolving sense—which has been growing in my consciousness as I get to be a proud old woman—about the rightness of things which happen in the natural way.

Clearly, I no longer have any need for the illusion of fecundity, having joyfully produced four bright and healthy sons. Moreover, at fifty, I realized the blessings of retiring from the "hetsex" mode, having "come out," or—as I chose to describe it— having come *into* the comfort of the enormous possibility of women-loving-women. I had come to see a larger picture in which the engulfing myth of gender difference was a means to control women and render them a docile servant class. "Femininity" had come to feel like a trap. I had come to be what Alice Walker, in her preface to

In Search of Our Mothers' Gardens, calls "womanist" rather than "feminist."

Now, nearly sixty, I feel that I have fully escaped compulsory eternal femininity. What I want these days is simplicity and self-sufficiency, and to embrace the status reserved by the medieval church for widows: that of the contemplative. In everything I do, I want to affirm rather than apologize for the progress of my body toward its ultimate condition. I trust it to do its aging without interference.

Gayle Lauradunn

DIFFERENT MOON

Thick heavy clots
fist size
push out
of her vagina
on no moon schedule.
Pain shooting up
the back of her head
down into her feet.
She is twelve
and believes in death.
Soon enough
it's a two-way street.
Clots coming out.
Penises coming in.
She believes her vagina.
She believes the orgasms.
She believes who she is.
Then the swelling.
This time she pushes.
Feels her son
make his slow way
through her vagina.
The ultimate orgasm.
She believes who she is.
She is thirty-three.
They cut

the soft skin.
She believes the knife.
Extract
all the clots.
The breeding uterus.
She believes the dark.
No pain now.
No clots
pushing out.
No baby
making passage.
Only penises
caressing their long way in.
Only orgasms shooting
up the back of her head.
She believes who she is.

Muriel Karr

MENSTRUATION, APPROACHING AGE 44

Sylvia being ecstatic at the surgical cessation, I still seek my apparently involuntary connection to the priestess element, Woman in long robes lifting a bowl to the moon. We can't explain it to men exactly, but I have brought to two of them the bleeding cotton wad like the almost living heart of an animal sacrificed for a holy purpose; they didn't "get" it, want never to see such evidence again.

I like it best glistening and painless, but trickle or flood it tells me: despite any doubts I'm female; life and I have cyclical rhythms; my body exists; my inner world exists, with patterns I don't control, and need to emerge independent of what I think of as "me"— my preferences, my recollection.

I count the interval days, waiting for the period of fertility to finish. Someone strangles me every 19 to 35 days. At a minimal level I breathe anyway. Regularity isn't everything. Sexual gender isn't everything.

But: gift, and mystery, and empty symbol. Christ on the cross. Cup containing nothing; still, a cup, poised to receive.

Rosmarie Waldrop

WINTER JOURNEY

1.

white white and white

disproportion
detour
edge

dear K don't count
the time I've been away

if we look steadily
at a color
the eyes see it as white

room
sheet
snow
around a repetition

don't count the time
I've spent

(by the well)
(next to the gate)

is it called distant
is it called remote
is it called

boundless without name
voice within tell everybody

given: freezing rain

don't look for what
(carved its bark)

2.

no less under the skin
(carved its bark)

white silence
a new perspective (drawn)
by knife's edge

look steadily
wherever in winter
contrast of white and white
and quiet

(I closed my eyes)

3.

whiteness
weathervane
wind

the snow
steadily

if we then look at
another color
the eyes tend to subtract

hard inquiry into
liquid edge

and desire: coiled
thick slow language
(fo(u)nd words)

dear K don't look
for what I've left behind

4.

the eyes adapt (the white, the white, the white)
(right in my face)

that is, the second color
moves toward the

complement
of the first

or a kind
of indifference
this side of

a knife
across inner surfaces

(I didn't turn back)

5.

do not follow my thoughts as far as

white glove
 mask
 coat

look steadily
white hair (pin) curve
of cognition

strenuous
vernacular
(fo(u)nd words)

entailment
of body

6.

as bitter winter
don't look for what I've left
steadily

do not dear K

for after-images

VITAL SIGNS

Sometimes I am asleep; sometimes I am awake. Sometimes I understand what happens around me; sometimes I understand nothing at all. Sometimes I think that I am in a bed with a curtain around me; sometimes I think the curtain is wave after wave of the tide coming in, only coming in vertical to my horizontal. Sometimes the sound of the tide is not water, but words. Sometimes I am asleep before I know are the words life, or are the words television.

▽ ▽ ▽

Doctor shows are hot this season, and I watch them, all of them. What doctor show doctors do—besides sometimes falling in love with women who go out on their surf-boards and drown—is the doctor show doctors fight diseases whoever heard of except maybe other doctor show doctors, and do operations just in the nick of time.

Operations are nothing to look forward to, even by a doctor show doctor, so when the time comes that is close to past the time to start paying attention to whatever is wrong, I do not call my personal doctor who has a history with me of taking things out. (I should probably say what they were, the things he took out, that they were babies and after-births, but babies and afterbirths make a history, nonetheless, and we have had one of each this year.) What I do is I call two other doctors from two other specialities, but here I am, scooped out like a grapefruit, and here my doctor is, just like someone wrote the script.

▽ ▽ ▽

Well anyway, after a length of time that I don't know how long or which week, even, I open my eyes, and where I am is in a room where there are flashes of light on the curtain around the bed that I am in, and then there are words and then flashes again, and so forth.

Even with the words being too low to tell who is saying them, you probably don't have to watch all the detective shows either to figure out that words and flashes together mean a television, and

where there is a television, there could be a someone who is watching that television, someone who you could maybe ask what the day is, or the week, even, and is there someone who could cover your foot, which is outside the blanket where you can't get it back in, and is cold.

Then again, maybe not. Outside of she could be sleeping, with this woman I might have a history. Because of the very curtain around the bed, who knows? she is maybe the same woman from before, the woman with the visitors. If she is the woman with the visitors, why will she want to tell me anything, and who can blame her? I mean how could she carry on a decent conversation with these visitors or even watch television with these visitors when there I was almost right next to her, and screaming.

Mostly on the doctor shows, unless there is some great moral or something that needs another person, television patients have rooms to themselves and no one they disturb when they scream, if they scream, which mostly they don't. On doctor shows, they are mostly brave.

▽ ▽ ▽

Besides, there is my own television inside the curtain that has a box for the coins, but I have no coins for the box and no glasses on to see the picture with. The television on my side of the room is connected to the wall on the side of the bed where the curtain isn't by these tube-type things. These are not the only tubes inside the curtain, or the only connections. At one end connected to me there are other tubes, skinnier and clear, plastic they look like, and these tubes are connected to something at the other end that blinks and something at the other end that drips. Two blinkers, one dripper.

From having babies, I know first-hand what the dripper is.

On the doctor shows I have seen machines that blink, but the ones in here, the machines connected to me, do not seem like those are, not that dramatic. Mine do not have screens or wavy lines across them, coming and going, just red lights that go on and off and on and off. My machines don't beep, either, like the machines on the doctor shows do, or have people standing around in front of them saying, "Don't die. Don't die," which does the trick. Or doesn't.

▽ ▽ ▽

Sometimes there are these crazy ideas. Here is a crazy idea: A television is on but I cannot hear the words. Instead, there is the

screaming and this idea, which is that if I have "urinary output," the nurse will bring more pain killer, even if it isn't the time.

"Urinary output" is something you have to know from life. "Urinary output" is something that when you have a baby, they won't send you home, the doctors and the nurses, unless you have enough of it written on this chart thing they keep. When they look at the chart on the doctor shows, the doctor show doctors don't say "urinary output." Sometimes they say "vital signs" but mostly what the doctor show doctors do with the chart is they kind of smile or kind of frown when they look at it, so that when you are outside, and watching, there are things you just know.

About my urinary output, I ask the nurse to bring a bed pan, which the nurse does, which is colder even than a foot gets when a foot is out of the blanket. I sit on the cold and I sit and I sit and nothing happens, so I start to rub and to sweet-talk and to beg and I rub and I sweet-talk and I beg until I rub and sweet-talk and beg this trickle of "urinary output" into the bed pan. Maybe there is steam, it is that cold, the bed pan.

"See," I say to the nurse.

One thing about television, you can turn it off. One thing about pain killer, if the nurse gives it she can turn off the screaming. What the nurse does is she smiles and she says "Nice."

▽ ▽ ▽

Sometimes what the voices say is, "Move."

Sometimes what they say is "Pick your head up. Pick your shoulders up. Pick your arms up. Pick your legs up. Pick your body up. Move."

Do I have a choice? I mean, can I switch the channel or something? What you could say is you could say I am a captive audience.

Someplace where they hold me is this hallway that is colder than a bed pan, and with bodies that race back and forth, vertical to my horizontal.

Someplace else where they hold me is where sometimes I hear what sounds like these water sounds, kind of suck and kind of plop, and sometimes I don't hear any sounds at all; where sometimes there is this voice that says "uterus" and "ovaries" and "tubes" and sometimes there is no voice at all; where sometimes there is this smell that is the smell like my finger smelled when I cut it almost

off with the electric knife; and where there is this light, everywhere this light, so much of this light we could be on a set.

<center>▽ ▽ ▽</center>

Sometimes I open my eyes and there is a shadow on the curtain and then there are ripples in the curtain and then there is my doctor.

"Could you hand me my glasses?" I say to my doctor.

My doctor picks up the chart. My doctor smiles. "With your history, you will be better off," my doctor says.

He is the doctor.

On doctor shows, you are either better off, or you are dead. I am not dead. What I am is all of a sudden this kind of hot that is prickly all over, then all of a sudden I am not hot at all, or prickly either, and then again hot, except for my foot.

"Could you cover my foot, please?" I say to my doctor.

My doctor examines where the tubes that are connected to the blinking machines at one end are connected to me at the other end.

"Nice," my doctor says.

My doctor is smiling a big, proud smile, the biggest, proudest smile I have ever seen him smile, prouder even than with babies and after-births.

"Lateral incision," my doctor says.

I know what the words mean, but not what my doctor means, or why my doctor is smiling that way.

"Lateral incision?" I say to my doctor.

He says the words again, "lateral incision," one syllable at a time.

"You know," my doctor says. "Bathing suit? Bikini?"

Bikini I know. Bikini I know from television.

"Do you have fifty cents?" I say to my doctor. "Do you have a quarter?"

There is a flash of light and the television blinks to life.

"Welcome back," the doctor-show doctor says in this voice like the sound is not on enough.

"Thank you," I say. Then I shut my eyes.

Joyce Thomas

DES DAUGHTER*

Freshly bathed, cleanly shaven,
you are ferried down the corridor
on a complaining guerney
toward an open elevator.
The anonymous attendant presses
one of the small numbered moons
newly risen on the wall:
pale disc, it glows,
weighted doors slide closed,
the chamber drops.
Your descent is uncommonly gentle.
When it stops, you are spirited
into that too-bright room
where masked men, a lone table, wait.
You are lifted onto it—
buttocks fixed at the edge,
soles securely fitted in two steel stirrups.
Above the green gowns transparent gloves
drift like oddly swollen, severed buds,
whose unfolding you watch
until you begin the count
backward from one hundred.
At ninety-three you break
free of all flesh, which goes
under the knife.

You awake to a name.
Over and over it is called,
so monotonously cast on the air
that its hook must catch, draw you
back into the light and that flesh
whose wrist the chanted name rings.
Half the time they will speak to you
in tongues—*laparscopysalpingectomy*
oophorectomyhysterectomy —

the other half, in tried and true
cliches— *good as new, smooth as silk,*
play the piano better than before.
They will bless their drowsy princess
with a pat on her head:
she has been good as gold,
the obedient daughter
whom mother wanted
and so dearly got.

You will be left
to finger the red line
running down the belly
and across the groin,
the skin incised, pieced and sewn
in scrupulous stitches like impeccably
matched teeth: such perfect craft,
reminiscent of your great-grandmother's
prized Jacob's Ladder quilt
passed on to her daughter
down to your mother
down to you. Snapped skein,
in a year that hair-line
fracture will vanish almost.
Hereafter you will dream of lofty eggs
that fall like lunatic planets
at your feet, the rich yolks
voided in a golden stream
encrusting dead stone;
and you will wake
to the sound of distant horses,
haunting cobble strains of all
the king's men retreating
on their exquisite
gelded steeds.

*DES, Diethylstilbestrol, a synthetic estrogen was routinely prescribed to preg-
nant women in the 1950s and '60s to prevent miscarriage. DES daughters and
sons have been found to be susceptible to various cancers of their reproductive
organs.

Barbara Lucas

THE GYNECOLOGIST'S OFFICE

The waiting room is filled with two kinds of women:
round and flat.
The round women are surrounded
by husbands, mothers, friends, children;
the flat women are alone.
The round women don't look at them,
not wanting to know
what grows in a woman's body
after birth.

The round women are called first.
After they leave, the waiting room
becomes very quiet.
Then the flat women are called
and led into cubicles where they undress.
Sitting on the edge of metal tables,
they await the assault of rods and hoses—
the breaking and entering,
the suctioning out of lethal nests,
blood clots spilling on the floor
like black roses.

When the doctor doesn't find anything,
the women smile and write a check
for $200, the price
of six months' worth of hope
that death has not yet taken a name.

THE REVENGE OF THE MENSTRUAL BLOOD

well, who likes lying on her back, naked, vulva gaping under the gaze of an unknown, fully-clothed male, her heels (socks still on) poised mid-air in cold stirrups, feeling like a jockey fallen off her horse

annual exam, age: 47, white spots discovered speckling the outside of my vulva; off to a specialist, tops in San Francisco, typical male doctor, i.e., composed, paternal; explained everything like a good teacher: yes indeed these could be cancerous

examined me and diagramed me: his drawing looked like a polka-dotted paramecium! I imagined him returning home at the end of each day, head full of ciliating vulvas

my periods had petered out, then nothing for over three months; biopsy morning, blood started to flow; called the doctor's office and they said come in anyway; flow got heavier; I arrived jammed with super plus tampax

got settled on the table, the doctor working on his own, swabbed my vulva with a vinegar solution, shot me with a local anesthetic, ooooeeee, the worst part; sterilized biopsy punches lined up, bald head bobbing between my legs

tampax string in the way, so he took it out and whoosh! big blobs of blood gushed out, covering his plastic-gloved hands, running onto the floor

he was furious, trying to restrain himself: bald head flushed pink, hands shaking, trying to stem the flood, but the blood kept pouring out, months of it! he was blotting frantically: my vulva, my legs, the table, the floor

it was the last time I bled; the famous gynecologist didn't speak as he chased after my body's wild outburst

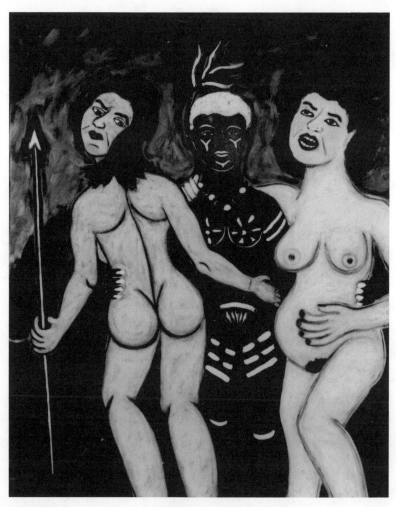

Jane Orleman

PROTECTOR, HEALER, CREATOR

IV ▽ THE MATRIARCHS GROW OLD

Wise Women

Darby Penney

MOTHER ROAD

Warm spring rains blow veils across the lake-face,
skirt forest and cliff-edge. Creek-rise,
cloud-cover, rivers thickening with fish.
Pale shoots, new sedges, weeds,
unbroken green just before the pink of bud swelling.

Everywhere women with high round bellies
lean back on their heels, breathing secrets.
They recline in the shade,
sleeping in season, steeping
like tea, the warmth
of the circling body brooding.

I walk the shoreline, little beach stones
dent my bare feet. Motherless, daughterless,
bloodless, my brooding is the only other kind.

Hardscrabble hill rises sharp
above the lake, a scatter of bent pines,
lone oak, eagles tilt and lift at cliff-top.

Strong legs, my belly flat and empty,
through the brush I take the back trail,
climbing. The cushioned floor rises
damp and pine, rain taps at the leaf-roof.

Loam, rock-lichen, bare rock and sand.
Above the tree-line, I stand rooted.
Distance is the vastness chasing after us,
spiked peaks, a hard vista
stretching northward.

Eve Merriam

TOWARD THE TIME OF MY LIFE

Heavy, heavy, what hangs down?
Lax my belly, pendulant my breasts;
Tap tap tap tapping the sap,
my final mead outpour.
The tree of life I have borne, I bear
leaf-laving more.

 But look, leaf seres brown on the bough,
 the edges curl back black,
 a yellowing paling fall:
 sigh dry amen.
 Accept your menopause as you must
 and turn to autumn dust—

The years and years and the seasoning years
increasing I praise;
unremaindering my days.
(And among the practical heroines I muse
Ninon de Lenclos greeting her sweetheart
at a heigh old age
and meeting herself with equal pleasure
likewise I'm sure . . .)

The making of love
is more than child's play.
As love is made in many ways and places.

Then grown beyond childbearing years,
the cords worn frayed,
must I be affrighted?
Take myself for a splayed cat,
of Tom tame,
broken and bound?
Benighted my days,

tied up,
all sensory censured,
cut—?

Gush water from rock.
Submerge in the drownest sea and find footage.

Mirror, mirror on the wall:
what do I fear the most of all?
 Unusefulness.

Aging glass that I gaze in:
reflect in me the deadliest sin.
 Boredom.

Passing fancy, tell me plain:
will my husband true remain?
 Be concerned more for his wife
 and her faithfulness to life.

Grace Grafton

GARDENIA WILTED SKIN WILD GRAND-MOTHER MOIST SEDUCTIVE

Woman wearing the white leather
gloves of her youth
weathered to spongy dew
Stroked petted
kissed fertilized
Oil-green sharper leaves
garden's edge, velvety
flower celebrating age
old ecstasy
Gnarled clitoris
spreading pungent
cream-wrinkled lips
wildly into day
wildly into night

Faye Moskowitz

THE MATRIARCHS GROW OLD, MY MODELS

The matriarchs grow old, my models, women who were women when I was a child. Who will be left to call me "Faygele" when they are no longer here? With no one but me to recall my childhood, who will validate the memories? They will carry pieces of me when they go. How much of their strength will they bequeath to me? The years pass, and the distance between us collapses in fan folds; one day I will be standing where they are now. . . .

Home, after work, I turn on the answering machine, pen in hand, to note the names and numbers. A buzz, and then Aunt Lena's voice floats out of the recorder, no ear to cup the sound before it fills the room. "I'm sorry to be the one to tell you this," she begins, and I feel defenseless, somehow, against the disembodied message. "Aunt Rachel passed away last night," she says. Where are the muffled drumbeats, the clamor of bells? Only this scratchy old-time radio voice, trapped in vinyl tape.

I call my husband to impart the news, discuss with him the best way to inform his aged mother that her sister-in-law is dead. His mother has had a hard winter, and we are fearful of jarring her fragile equilibrium. We decide to tell her at dinner, the first time we will be together again that day.

Seated at the table, we avoid her eyes, drop our glances away from the shaking hands, attenuate the time until the announcement. It hurts to imagine how she must feel, on the firing line of old age, wondering if she will be the next to fall. "Let's get it over with," my husband mutters. His mother doesn't hear him; she is quite deaf.

I will be the one to say it, I tell myself. Perhaps I can phrase the words more gently than he can. But I quail at the deafness, the problem of delivering bad news at the top of my lungs. The possibility of nuance is gone; I cannot soften the harsh words by a lowering of the voice or the gloss of inflection.

"Ma," I say, at last, raising my voice, "Rachel passed away; Aunt Lena called." The piece of bread is halfway to her mouth, and she

continues to carry it in one unbroken sweep. "Tough woman," my husband says of his aunt. "Rachel was a cossack!" his mother affirms. I look her full in the face now. She is dry-eyed, a tough woman, too.

I wonder how tough *I* am, now that the years stretch behind me in a swath sufficient to reveal texture and design. Are there surprises left? My responses seem to me these days as predictable as the tobacco-covered pennies that turn up at the bottom of my purse. The women of whom I speak: their lives were tempered by pogroms, the blast from gas ovens. They endured loss of land and language, answered to "green horn" before they knew what the term meant. By contrast with them, my life has reached the soft-ball stage in the likes of a jelly kettle. I pray I never endure their crucible, but I covet the nature of their strength. . . .

The world tastes flat—meat without salt, more often than not. I know how fortunate I am to have been born in my own special time and place. Still, that doesn't cheer me when I get the blues any more than the example of starving babies in China ever made leftover food more palatable when I was a child. I ponder the years to come and see mixed messages everywhere I go. . . .

Three elderly ladies share a bench at the neighborhood supermarket, crocheted shopping bags and metal carts tucked at their sides. Dressed for the season, they sport dark, flowered polyester dresses, good wool coats, and tidy hats. The few minutes of gossip they exchange add importance to an errand already blown out of proportion by the meagerness of their days.

A similarly clad shopper passes the seated group and calls to one of the bench warmers. "Hi, neighbor," she says. A blank look for response, and then, "Why! I didn't recognize you!" Halfway to the exit, the first calls back crisply, "You never do." "Well," says the seated neighbor in self-defense, "You've changed so." Shoulders slumping, the departing woman mumbles to no one in particular, "Don't I Know it!"

At fifty-two, I feel changes also. Not since my teens, the years when we are all eager for the clock to speed up, have birthdays provoked such introspection. I was conscious of the passage of time back then in a way the intervening years have never mirrored. Too busy, perhaps, bearing babies, raising them, finally growing up myself, to watch the clock.

For a long time, I approached birthdays calmly, counting out

the comfortable number of years I could reasonably expect according to the biblical formula (as good a measure as any), and always the three score and ten allowed me more than half of what I had already eaten up. After I reached the "halfway" mark, I changed the rules and began to measure by actuarial tables; still there was comfort in the numbers. Now, add and subtract as I may, the balance is against me. I find more years gone by than I can hope to have in store.

For the first time, I wish I had some of those years to live over again. That beautiful decade between forty and fifty: I wouldn't waste it sleeping so much, dreaming, staring at walls, doing crossword puzzles, listening to the stories of people I don't really care very much about. Things are different now that the moon is no longer my timekeeper. The depressions can't be so easily explained away by a knowing glance at the calendar. I wonder if I have time left to write a novel; will I ever shape the hoarded bits of brightly colored fabric into the quilt I have always thought I'd make one day?

The hair I swore I'd never cut, "until I die," I playfully said, hangs heavy, makes me question long-range promises. My daughter told me tactfully not long ago, "They have great hair coloring now; you should really think about it." I do. My students beg me to let my hair hang loose instead of bound in a knot, and I brush them away like insistent flies. I don't want to look like the women I see in the country with Dolly Parton pompadours and sagging faces underneath. Nevertheless, I understand about outer changes. What the poet Robert Frost calls "inner weather" concerns me more.

The days whirl by in a rhythm of their own, freewheeling, out of my control. I grab at the nights with my fingertips and cannot hold on. Be productive, I tell myself, not certain any longer just what my quota is. I write, I teach, I mother and wife, I eat and drink and read. But my shadow shortens and threatens to catch up with me. I look to the matriarchs for their secrets and see they are falling. They speak to me with words that echo Eliot's *Wasteland*. "HURRY UP," they say. "HURRY UP PLEASE, IT'S TIME."

Julie Herrick White

EYES

The woman told herself
that she couldn't commit
suicide until her quilt was finished.
It was one of those dialogues
she held privately,
nights when she would have liked
to shed her homely menopausal body
like slipping off the old cotton
nightgown with its worn-out
shoulders and broken seams. Instead
she mended the gown,
taking those tiny, even stitches
she had learned as a girl.

The stitches came easily now,
and at forty-seven she had given up
the structured quilt patterns
like Log Cabin and Inverted Fan.
She had committed one great act of daring
and started a crazy quilt.

The silks and velvets comforted her,
and she threw pieces here and there,
cutting how she liked
and watching them fit together
with a shiny, sinister beauty.

She took from the egg money to buy
more satin and taffeta. She didn't care
whose money it was any more.
She wondered about her own body,

crazy in its new mystery,
no pattern making sense.

Nights she worked downstairs.
A clock chimed three. Then three-thirty.
A few birds started. How could those
birds sing in the dark? And why had she
cut two circles of blue taffeta
that shone out in the center like eyes?
Were they friendly or unfriendly? She didn't
know, but she took her stitches
more slowly,
trying to make them last.

Valerie Nieman Colander

SIDESTROKE

Two by two,
the old women swim
with faces canted from the water,
turned toward each other as they draw out
a long conversation. Cupped hands
measure water in cloth-yards
as they meet, extend,
meet and extend.

They are modest
not of their great fleshy bosoms
and buttocks, but of their arms,
solid from shoulder to wrist. When they turn
their arms rise briefly, whitely
from the water to be inserted
back, their power
concealed.

Once young flesh buoyed
them, the moon incited or lulled;
in the long middle years they each day
spun a cord to bear the weight of others' lives,
(chord strummed, chord bisecting an
emptied moon); now in age their
wakes unravel and disappear
into a skein of water.

Gayle Lauradunn

THOUGHTS ON A LETTER FROM ARIZONA
". . . flowers seeding now—and still they
blossom in the dry sand—you can kick them,
by accident, and the roots are gone and flying.
Love, Jean"

Like blossoms in the desert
we flourish brightly for a moment
carrying the color, sometimes, into
the dry thickening of the middle passage

where the roots grow deeper
take a stronger hold—or else
they turn to wings, carry us
into, perhaps beyond, our dreams.

Lucha Corpi

LENTO LITURGICO
A *Catherine*

A veces la voz se me adelgaza
como una gota de luz
que se va quedando dormida
en el medio de la lluvia
—una pequeña cápsula
de silencio en donde guardo
mi nombre envuelto
en un pañuelo negro—
porque a veces la mente sufre
desmayos prematuros
y el espíritu aminora su latido
y se me escapa por los poros
como un sudor febril de invierno,
porque a veces le faltan fuerzas
a labios y dientes y lengua
para destrozar en mil pedazos
al desafiante espejo de los ojos
que me anuncia la llegada de
la irresoluta indiferencia del blanco.

Y es que a veces me consumen
el miedo al olvido, a la ausencia
a la carne flácida, al tiempo
al vientre desprendido de su ritmo;
y así me voy quedando muda:
Las cuerdas vocales desunidas
de su generador interno
me paralizan la boca del alma
mientras en la pantalla de mi vida
se proyecta fugazmente
el lento litúrgico de mi invierno.

translated by Catherine Rodríguez-Nieto

LENTO LITURGICO
To Catherine

Sometimes my voice thins out
like a drop of light
falling asleep
in the rain—
a little capsule
of silence where I keep
my name wrapped
in a black handkerchief—
because sometimes my mind
faints before its time
and the beating of my spirit slows
and escapes through my pores
like fever-sweat in winter;
because sometimes my lips
and teeth and tongue lack the strength
to shatter into a thousand pieces
the ominous mirror of eyes
that signals the onset of
the irresolute indifference of whiteness.

Because sometimes I am consumed
by the fear of oblivion, of absence,
of flaccid flesh, of time,
of my womb torn from its rhythms,
and so I fall toward silence:
Loosened from their internal generator
my vocal chords
stop the mouth of my soul
as the screen of my life
flickers with
the *lento litúrgico* of winter.

MOON GARDEN
an excerpt from the novel, *SEEING THINGS*

Harrison has asked Carrie a leading question: "Why is Selena such a *subject* to you?"

She has offered him lunch there in the garden before his appointment in the city. She is placing the contents of the luncheon tray on the wrought-iron table with its glass top and has motioned him into one of the wrought-iron chairs. Harrison notices that she has made a cold avocado soup. He does not like cold soup. The sandwiches are of cheese and alfalfa sprouts. Can she be a vegetarian? An alfalfa-sprout salvationist? The table is below a gigantic avocado tree that does not yield, the avocados in their soup having been trucked up from Mexico. The tree shades their faces, but Carrie is uncomfortable.

In fact, she is embarrassed. She feels turned inside out, completely vulnerable and conspicuous. At the same time, she knows that it is all in her mind, as one of the symptoms causing her embarrassment. Menopause! The end of moon change!

It has happened suddenly, just as menstruation did, she recalls. She feels like an adolescent, too. She remembers her daughters just a few years ago and wishes they were here to laugh with her as she laughed with them over the discomforts of their growth. It isn't considered growth at the end of the cycle, she thinks, but a kind of decay. And yet she feels like an adolescent, giddy as a girl.

How often in those years of lying alone Carrie has been annoyed by the uselessness of her cyclic bloodletting. Yet as it wanes now, coming in unexpected clots, sometimes seeping onto her skirts, as it did with her daughters, and stopping its flow as suddenly, she feels regret. Life is undeniably waning, but it isn't decay. Surrender maybe. The end of her long marriage to the moon, perhaps not as painful as the end of her human marriage but more poignant somehow, in its way surely more personal.

We have noticed that human visitations to the moon have not altered its force on earthly life. Some tribespeople like the Maoris think the moon is the permanent husband, true husband to all women, its slender scythe cutting in a ritual deeper than a

husband's. Carrie does not imagine herself more understanding of the world than a Maori tribe informed by long service to nature. The moon as male and female has taken her and used her for many more years than she needed it, yet her life's movement is tied to the moon, turns toward it, making a few last spasmodic gestures as she is released from its demands.

She has not yet answered Harrison's question, being aware that he does not like the lunch. What a difficult person he seemed to be! Contradictory, as full of jerks and starts as she feels herself to be during this period of change. She finds she cannot eat the lunch herself. She is disturbed now by an odor in the garden, so pronounced and repugnant to her she feels she has to apologize for it. But no sooner does she suffer the apology than she blushes, her face coloring in blotches, for she realizes that it is not from some fertilizer Ginseng has been using but is the pungent smell of an animal marking its territory. She glances at her cat, spayed two years before, usually a fastidious cat. How can it be? Harrison, to confound her further, shakes his head. He denies smelling anything and shrugs indifferently.

▽ ▽ ▽

Carrie can scarcely breathe. She takes a sip from the glass of iced tea beside her place. Can she imagine it? Can she herself be the source of the odor? It flows across her nostrils like an effluvium, fetid, pervasive, a much stronger smell than cats in the garden have ever made, goatish, unfamiliar, the smell of rut.

And as suddenly as it has filled the air, it goes, and a sweet breeze bearing the scent of her rose blossoms allows her to breathe again.

Harrison is inquiring about the sound of water from the other side of her studio. Out of his sight there is a pool, where we hear a faint but constant sound of splashing water, a soothing plop with a lingering vibration. Ginseng's experiment in Oriental gardening, she tells Harrison. The water falls in isolated drops into a clear pool that drains over seaworn rocks and is moss-encircled. Street noises from beyond the garden wall interfere with the continuity of the sound, but in moments of quiet the drops fall in calm resonance.

"I'm thinking about your question," she says. She realizes that what Harrison wants to know is whether she shares Selena's fascination with the occult. "Selena is a subject I don't tire of, it's true.

She moves. There's nothing static about her, no way to freeze her in time and space. A challenge."

Harrison says, "It's all fantasy, you know."

Carrie looks at him until he has to glance up at her, then says, "Go on."

Her brevity disconcerts him, tempting him to be equally brief and scornful. As a matter of fact, he wishes Selena Crum had never introduced him to Carrie, because it is like being handed some not inconsiderable reality, like having an orphan baby in a blanket dumped in his arms by a crazed woman babbling with a broken accent.

"Well—" Harrison begins by looking at her eyes, which are so clear and direct he has to shift his gaze to her hands, where the wear of her work is evident, her fingernails as stained as his own. He thinks: She's an artist, she ought to understand. He says, "The sculpture—it shows me you must think about the primary problem— what in hell we're doing here." Carrie only nods, waiting, which makes Harrison all the more aware of his own uneasiness. "Simply to accept a system like this crazy DU," he says, "it's nonsense. Why is one theory any better than another? Why not forty-seven chakras instead of five or six; what if Buddhas float on clouds alongside of ascending Christs; what if there are Tibetan monsters stabbing Greek gods?"

I'd hate to tell him, but that *is* the way it is. Totally chaotic, everything ever conceived. Harrison's education might lead him to think the Greek gods, as the foundation of Western culture, are the most interesting and audacious, but he doesn't know what is happening. He doesn't have to know—many people don't. And many more couldn't tolerate the really weird mix of Scandinavian, Tibetan, Hindu, Chinese, Christian, Aztec and Egyptian lords, not to mention their various prophets and sages, recently roused from their slumbers and all communicating frequently with some earthbound person. No wonder groups like DU proliferate. Humans have a need to try to bring order out of chaos. Harrison knows this, but he says, "Why close off any possibility?"

"But you've just done that," Carrie points out calmly. "You said DU is nonsense."

"It's making some absolute assertions," he asserts. "That's even potentially dangerous, aside from its stupidity. It leads to such engaging heroics as the Crusades, for example, or the dunking and burning in Salem, not to mention more recent forms of spiritual fascism."

Carrie thinks of Harrison's own experience in the outer world, where his inventive devices deal with social manifestations of chaos. She says, "I imagine you must worry about the value of what you're doing sometimes, about whether you're right or not. Or whether what one person can do in a practical way is of any use."

This evaluation annoys Harrison immensely. It is accurate as far as it goes, but it strikes him as a complete evasion of what he's been saying. It's true, his mode is oblique. He hasn't just come out with the fact that he thinks Carrie, with her visions and spells, her obsessional working of one figure over and over, is in need of medical, probably psychiatric, attention.

"I used to think I was crazy too," she says maddeningly. Recovered now from that olfactory trance, she reaches for her sandwich, taking some of the alfalfa sprouts in her hands. She places them between her teeth with her fingers, making Harrison more aware of her creatureliness, her unavoidable bond with the kingdom of those who feed themselves with their paws, who conjoin, reproduce, digest their sprouts, defecate, and die, untroubled by the dreadful human problem of cosmic awareness. He does not want to hear her tell him she *used* to think she was insane but rather that she *is now*, and that she is going to have herself committed that very day and taken out of his range of concern.

She says, "After all, it's peculiar to have people who are dead or who you don't even know wander in and out of your garden and realize nobody else can see them." Here she gives a light laugh. "It's crazy!"

Carrie's calico cat is stalking something and leaps up on top of the retort head, where she glares at a thrush in the arbutus tree. She springs up onto one of the branches of the tree, leaving the machinery unbalanced. Harrison says nothing, thinking that Carrie hasn't noticed. He plans to return as soon as he possibly can from the city and retrieve his material (and his *life!* he thinks a bit presumptuously) before that animal can destroy everything.

"We can put it in the studio before you go," Carrie says.

He blurts out, "I don't like having my mind read."

Carrie laughs. "Oh, were you thinking the same thing?"

"Thinking what?"

"What I was thinking. I can't read minds, you know. At least I don't think I can."

Harrison bites hugely on his sandwich. "You've done it twice."

She waits a moment. "Maybe we should tell each other what

we were thinking. It couldn't have been the same thing after all."

Harrison doesn't answer, is wondering that this small woman has made him aware of how cranky he has become. Like Carrie a few moments before, he has a passing difficulty in breathing. He feels a physical cramp in his belly, not from eating the infant alfalfa but from being cramped in his psyche, invaded. He realizes a fear that she has it in her power to take over; after all, she was a woman, wasn't she? Everyone knew that women call the shots even if men do fire them. Why else has he stayed away from women for so long, if not to avoid the insanity of human aggressions? He has his scientific projects. He can rely upon them, but life has proved, since his Catholic childhood, a perilous process, a shoot-or-be-shot situation, and Harrison, as he has said, has no yearning for absolutes. He likes the element of doubt science demands, which has filled the gap faith left in him, a faith he had buried along with his wife, who died in childbirth. He seldom thinks of her, never if he can help it, yet there she is now, lying in that glittering hospital where his child had tried to come to life, dying of childbirth *fever*, an obsolete disorder of the womb which had somehow gone undiagnosed. Surely one of the last women in modern society, he imagined, to die in childbirth. He had been done with women since then; his unresolved pain could riot in his dreams, startle him awake and stalk him on insomniac walks through the Valley of the Moon, but daytime would come, and he could go back to work.

Carrie is interrupting these reflections (Can she have read them again? he wonders with a start). She says, "Many of the things I see don't happen, are as impossible as dreams. Some are distorted memories. I used to feel disturbed by it. But lately I feel strengthened. It's because I have changed. It's a tiny move, to believe, but it changes everything. If you can believe life is a divine trust— well, that sounds pretentious—"

"Go on."

"Trust sounds too solid, like a bank. What I feel is just the opposite, a lightness." She gestures again, as if trying to create a stack of layers of lightness with her hands. "What an enigma! Words are the best thing we have for giving information, but they're useless in giving —in receiving—" She stops again, shaking her head.

"Giving what?" he insists.

"I want to use another word like trust, but it's even more difficult."

"Grace," Harrison says harshly, finishing it for her, reading *her* mind, dredging up one of the loaded words of his childhood.

Carrie, who cannot read minds, reaches out and touches his sleeve. Her voice is carefree, almost caressing. "Why, Harrison, you didn't tell me you were a mind reader!"

Then she is suddenly aware of her earlier embarrassment, and now it invades the lightness she has expressed. She feels awkward again, adolescent, and she recognizes what it is. She wants to be touched, held—if not by this man, then by another. How awkward, she thinks, for these feelings to be aroused, visibly surfacing, spilling out all over the garden. She wants to burst into tears of frustration. The embarrassment of continuing all these years to want to be touched, embraced!

I send her word that she is engaged in a useless struggle, which she seems to hear, for in the next few moments she grows calmer.

A helicopter has begun to circle overhead, at first only as troublesome as a fly. But then it has closed in, making a hovering circle only two hundred feet above the garden. This is the police helicopter, the kind that brought on Ginseng's paranoid fit in which he destroyed his marijuana plants. It is a familiar noise because of the frequent criminal activity on College Avenue nearby. Carrie explains it to Harrison.

He has read of the bank robberies, the burglaries, the anarchy in the streets here. He glances again at his machinery—will it still be here when he returns? Should he take it somewhere else for safekeeping? Where was there a place in these crime-infested cities?

If Harrison is seeing himself as cranky today, you should not be misled into thinking him a simple crank. Think of him rather as the survivor of some other age, the age of inventors, say, since that is what he is, one in whom the ethic of the Western frontier still asserts itself. A farmer's son, he has a practical sense of the basis of that ethic: society valued an individual because his body was *needed,* if only as an earth mover, a tiller of ground. He sees the humanistic ideals people built around that as obsolete now, undermined by insane urban development, which has brought on the anarchy signaled by the helicopter overhead. Strong Elkhart, Bubba Burr, and other city spiritual leaders teach exercises for "sensitizing" the body; a drive into the city is enough to sensitize Harrison—his senses set off signals of fury at the stench and decay. What could a single human life be worth in a world that already looks and smells like

kitchen middens, heaps of stinking waste not quite rotten enough to be turned to any earthly good? The helicopter, its blades making futile thrashing gestures against chaos, grates on him, and now he can smell that odor Carrie has spoken of. He feels a disorder in the atmosphere even more intense than usual. Suffocated, he begins to speak aggressively.

"Selena's hope club, DU," he says, "it's just so much wishful thinking, group hypnosis. They've lived in cities so long they can't see themselves as part of nature. They glance away from their role in this strange world, in which all creatures devote themselves to tearing one another into shreds—biting, gnawing, gnashing, grinding—and they say they are devoted to human evolution! Every animal alive comes equipped with something it can destroy other living matter with; everything born looks for something else that has been born to gobble it down, consume it, digest it, and then turn away, only to be eaten itself." Here Harrison takes another large bite of his sandwich of baby alfalfa, while Carrie stares in alarm. He seems so upset! "We see this pattern in all life," he says, "and among men we are coming to understand that war is probably not a curable condition. Can the fiendish way in which we destroy one another be less natural than the ruthless earthquake that buries alive whole towns, or the tidal wave that washes over a quarter of a million people like so many shrimp? And what of the *shrimp?*" he goes on. "Consider how the sea destroys its own life every year. Do those in Selena's group who imagine human life is evolving ever think of their own relationship to the pine tree that scatters thousands of seeds from its cone in an effort to create a forest, only to have perhaps one small seedling rise to light in a decade, perhaps none. People are no more special than the thousands of infant ants eaten by the anteater, while one or two escape; than the turtles born of a nest of fifty eggs who rush to the sea, hurrying to the armored mouth of gulls, and possibly one among them able to mature in the ocean depths. We can only observe the same thing over and over; decay creates the fertilizer which enables birth, and there follows the multiple spreading of seed, from pine trees to humans, which leads only to more death, more decay, renewed fecundity. We live on a planet of creation and destruction so impenetrable that we can't understand it. Grace is a word for the past, and the inventions these psychics imagine for the future—the new Atlanteans and so on—are childish daydreaming."

Carrie is gazing off now toward the garden pool, which is out of Harrison's sight. He has been speaking above the whir of the helicopter, has had to raise his voice almost to a shout, and now falls into a gloomy silence.

Suddenly Carrie's calico cat springs forward and leaps upon the finch it has been stalking, as if to confirm all that Harrison has said. Harrison assumes that this is why Carrie rises from the table with a strangled gasp. The cat grips the finch, tearing at its neck, spilling blood on the ground cover of baby's-breath under the strawberry arbutus tree. Even Harrison finds the cat's appetite reduces his own.

But Carrie is not looking at her cat. She moves from the table toward the Oriental pool at the other side of the garden. Unknown to Harrison, she has not even seen the cat's luncheon feast. She gives a cry that Harrison cannot hear over the helicopter. An overwhelming scent of musk penetrates her nostrils, and Carrie sways before an outrageous sight.

Usually she has believed the things she has seen. They are familiar to her, although they are sometimes like dreams, as she has told Harrison. But she has never before seen a creature like the one who is standing there beside her pool. The sound of the helicopter ends abruptly. She is surrounded by silence, and her vision spins, tunnels. The garden seems to curve upward, to make a circle, and at the center of it stands the figure of a human-deer.

Someone else is with this being, who has staggered against a lawn chair, as startled as Carrie, a man she has heard of but never seen before, Strong Elkhart.

Carrie is to witness a scene between these two, Elkhart and his teacher, newly arrived to bestow further knowledge upon his favored pupil. How she is enabled to witness it is something for parapsychologists to ponder, or poets. I am neither, only a spirit guide, and can offer no explanation. But the two are there before her at her pool, just exactly as they are also at the Claremont Hotel pool as far as Elkhart is concerned.

Approaching a chair at the pool, Elkhart has suddenly felt weak. He has heard the roar of the helicopter making its searching circle overhead. As it has in Carrie's garden, the machine seems to circle above the hotel, just above *him*, and although Elkhart is inclined to favor helicopters, the sense of being stalked by some unknown hunter raises the hair all along his spine. And then he, like Carrie, smells the heavy odor of musk.

The Bielbog who stands beside the sunlit water is somehow much larger than before—his antlers many-tined and golden, his hide very white, but his feet no longer cloven. He has become more a deer and somehow more human, more dominating. He is smiling and very dangerous.

Elkhart is frightened. His desert mentor has been changed from a capricious, malefic horned imp, toward whom he felt some superiority, into a presence that shimmers with magnificence, so awesome in aspect that Elkhart nearly collapses as the support goes out of his legs. He falls into a chair, swallows dryness and aspirates, "My God, what are you?"

The creature makes no reply but looks about both garden and hotel, looks wherever those bottomless brown eyes may see.

I recall the misgivings I felt in the desert about the transformations of Elkhart's teacher. I realize that I myself am as afraid as Elkhart of what may happen now, that I share Carrie's surge of apprehension as she draws closer to look at the terrified man in the chair, at the lofty being, at its downy white chest, its impenetrable gaze. In all my work at the expelling of imps and demons, I have seen nothing like this. I might have worked an exorcism upon the Bielbog Elkhart knew in the desert, but I have no power now over what he has become. I listen fearfully for his answer to Elkhart's question.

The being speaks. The voice, coming from some deeps I have never penetrated, has yet a gentle sound to it, a strange tenderness, and at the same time, a lofty condescension. An indescribable fascination is contained in its sound, and its utterances are careful and slow as it never spoke in the mountain desert. Gone is the impatient tenor, the petulance. The lofty resonance that blends with that tender strain is like a necessary counterpoint in a fugue. But this being is beyond my descriptive words; even its own words intensify its mystery. The vibrant voice rises in a chant, spellbinding, sustaining an inhuman wrath.

"You asked me to name myself before, Elkhart, and I gave you Bielbog. And you wanted to know if I am the devil! Now again you wish to limit me by insisting that I have an identity. You see, identities are temporal and transient; I am not. If you had lived in Paleolithic times, I would have appeared to you in a deep, secret part of a cave, and for the occasion you would have worn a headdress of horns yourself and carried a box of ocher and treasured

relics. You would have painted the walls with pictures of animals and of me. With fire and dancing you would have evoked me. Our tête-à-tête, horns to horns, would have been about death—yours and the animals you might kill, a conversation simple and satisfying to me about death and rebirth.

"If you had lived millennia later in the age of open sunlight and free-standing sculpture, templed mountaintops and round theaters, I might have appeared to you as a white goddess rising from the water and gone with you to a cliff where you would chant in sonorous Greek. I would reveal myself as the creatrix, the eternal mother, the deliverer, the watchful eye, and you would swoon in ecstasy and love for me, as you now faint with fear. You might even grow wise enough to know that in every Isis there is a Hathor, in every life a death. I would leave you suddenly, for I never reveal too much at one time of an eternal pattern. You would be overwhelmed with wonder. You would seek me everywhere. You would find me in the logarithmic spiral of the conch shell, in the power and relentless motion of the whirlpool. You would see me reflected in the spindrift gaze of the sea lion. Twisting, whirling, eddying, reeling, my motion might be found everywhere."

The voice pauses, and in that momentary silence all of us are more conscious of our terror. Elkhart has thrust his knuckles into his mouth, chewing them as if they have been magically transformed into Knuckle Root, whose power, if he were to remember it now, might seem trivial. Carrie has had to sit down on the grass, her fingers up to her lips, and is again having trouble breathing. She is very sensitive to the smell of rut. Her own body is throbbing; the flow of blood she has suspected before seeps from her uterus. Her face feels like melting wax. And I—I tell myself I am only a vessel, a channel, and try to let my own fear out into empty space as the being speaks again.

"And in this forgetful age, you still evoke me. If you ignore the water, I come on the wind. Your weapons, which have always reflected me, as in the spiraling flight of the arrow, are subtler now but just as strong a call. I fly in your bullets, in their gyroscopic spin to their victims. Even the very atoms and their particles in orbit now are spinning out my deadly work. Spinning, spiraling, whirling, I can still make humans reel. And reeling, you try to gain your balance with definings, rules for religionists! Absurd! I am *never* what you think to find. You came looking with your love

of eternity. And now that you have forgotten the first rule, obedience, your plans are as irrelevant as dust. My gift is what you may receive instead. My gift to those who love me!"

In a weak voice, Elkhart says, "I only wanted to know the truth."

The majestic foot stamps, no longer the petulant stamp of an imp who has stolen a name; the sustained rage of that being is poised for release. The voice sounds again. "What in hell is truth? Have you the delusion I have given it to *you*? *I will* tell you this. Each age earns the god that it desires and deserves. I have come again in your murderous century, the horned one, the *cernunnos* beloved of barbarians. Someone here conjured me today, who spoke of the absolute, someone who understands what pleases me most— birth, death, regeneration. I gave you an invention, Elkhart, nothing more. Can you imagine I would give the truth away to a mortal? No, the truth is not my gift."

Carrie falls down onto the grass and speaks in an anguished whisper. "Oh, please—" Elkhart has broken into a sweat and lies groaning on the chair. The antlers turn on that lofty head; the ears twitch as if Carrie's whisper has reached them. "Let us live!" she cries.

It seems to her that the two beings telescope, become very distant from her and are slowly surrounded not by her sunlit garden but by the night sky, or rather that she is looking into a sidereal view, has fallen into a slow moment between two nights. "What *is* your gift?" Elkhart pleads. A sickle moon intervenes between Carrie and the distant pair, gleams on the antlers, then comes between Carrie and the two figures, draws closer to her, penetrates her body. She feels saturated with fluid. Her heart spins, flutters. She falls into a faint.

Harrison, who has been watching her, has also been distracted by the calico cat, whose cutting teeth have made quick work of the little garden finch. The bird has been processed through the side of the cat's mouth, with shearing teeth that have crunched the delicate bones, so that very quickly nothing is left but fragments of wings as clues to a tasty meal.

When Carrie begins to speak, Harrison runs to her side. He is very alarmed by her whispering plea. What is she saying? "Let us live . . ." Let *who* live?

The cat springs up onto the tree again, by way of Harrison's distillery, upsetting it. He scarcely notices. His earlier misgivings

about his material have vanished in the light of Carrie's apparently endangered state, and so too has his critical attitude of her.

He must save her, he thinks confusedly. What does she mean— let us live? Her voice, an anguished whisper from her will to life. Has *he* brought on this strange attack from which she seems to be suffering? Has the death of the bird affected her so strongly?

Harrison has a terrible conscience, the consequence of his upbringing, his asceticism. He has presented her, he realizes, with an unbalanced picture of the world, in speaking of all its death, of its habit of recovering itself at the expense of life. He has overlooked the sun! He gazes down at her; her face appears to have sunspots as she lies there in the bright daylight. The irony of his proud summation strikes him now, creating a steady pounding in his head. He sees the Oriental pool, and each of its sunlit drops of water seems to strike blows at his forehead; he seems to hear the resonances of a song sung in Greek floating in the sunny air—it is the shriek of a siren on the other side of the garden wall. The sun, which also enables fertilizer to do its changing work, now strikes him with reassurance, stirring his roots to life. He rubs his head, which has banged against more of his own rhetoric: Carrie lying on the grass is no longer an infant in a blanket; she is the surviving sapling grown up to the sun from the thousand spores of the solitary parent tree; she is the full-grown queen of her mother's anthill; she is the giant turtle who has made a hundred trips to lay her eggs upon the beach and left them there heedless of whether one will grow to her own size. *She* has grown, fortuitous or especially chosen—what did it matter? She was a being with days of grace, yes, left in which to thrive in that survival, in the sun.

All of this flashes in his mind on the length of a sunray, and he touches her cheek with its spots of red about the eyes. She is hot, burning. Her eyelids flutter open. Her hand goes out to cover the stain on her skirt, but Harrison scarcely notices. "Let me help you!" he cries, lifting her from the place where she has fallen.

A loudspeaker now comes from the helicopter overhead, a police voice sounding from the vortex into which Carrie's vision has whirled. "They went into Mystic Street . . . behind the Blood Bank . . ."

Carrie says, "They've robbed the Bank of America again."

She looks at Harrison and realizes a change in his attitude as he presses her hand, carefully settling her in the chair beside her

table. She sees that gloominess has been displaced by a panic not unlike her own. Yet she also knows he has seen nothing she has just witnessed.

Yet Harrison's own words have summoned that resplendent being—hadn't the creature said so? Harrison had been the one to speak of the absolute. It was Harrison who had evoked death, rebirth, and the ruthless way in which it comes about. Harrison, the unbeliever, has called up that being of majesty and mysteriousness.

Risen from her fall and looking at him, Carrie thinks of an old word which she hasn't heard since she sang it in a ballad as a schoolgirl, yet the word, *plighted*, resonates through her. Their pledge is unspoken, not yet recognized. Their plight, there in that garden surrounded by the siren calls of a collapsing society, fearsome and lovely, comes like a gift out of the vortex, late to their lives.

Susan Schefflein

THE VANITY TABLE

I take my place before the antique table.
Carved grape leaves inlaid with gentian flower
Curl slyly round the edge.

Wood panel lifts revealing the mirror
Of Mother's precious Vanity,
Tilted to receive my waiting face,
Fairest of them all.

I bare my breasts only in dreams,
In the public room, the place of prying eyes,
I cover them again
With white cloth smooth as open palms.

I am years swollen
With pretense and smiles
To please the Prince.
Evenings of Loretta Young

Swirling through an open door,
Standing on the dining room buffet
In spike heels
To give the full effect.

I've served my term.
A thousand tubes of lipstick past,
Powder puffs, cold cream,
Eyeliners ground away on half-closed lids.

Give me back my life.
This time, I'll make it real.

Laure-Anne Bosselaar

NOVEMBER CHILL

I am quiet tonight—as dusk grays
the lowlands behind the rusted gate—
and watch November give up its furrows
to winter, frost salted by the North Sea.

I gaze at the dry windows
of my eyes, how life's fever etched
stories there, subtle maps of weariness,
and lines I can no longer silence.

The hue that invaded the nasturtiums,
the weeds, the willows, penetrates the house now—
the chestnuts on the table, my words,

the meaning of things. I shudder,
turn on the light, hum a tune, gather my skirt,
and throwing back my hair, I dance.

Marcia Cohee

HECATE

Hecate of the crossroads,
the red sign above me says, exit.
Hecate, we arrive at a fork in the road
this desolate road
that has become familiar
as the veins on my left hand.
I bleed with the new moon.
I turn around and there is the desert.

Vultures spiral above us
as if I held each one by a thread.
If I sew, if I weave
the fabric is spare and rough.
If I count, if I name
every star in the Milky Way
it is you who have taught me.
Our brooms are not for sweeping, Hecate.

If I join you at the crossroads
if I leave my daughter to dance
and to call the birds by name
and to light candles by herself
to eat grapes from a new basket
on the doorstep, if I live instead
on the seeds of pomegranates
will I know this dark terrain
like the red furniture of my soul?

If I join you, hooded one,
satin cape in moonlight silver,
will you share your recipes
and let me stir the cauldron?
I who am old but have a daughter
ask you, who are thin as an ash in November,
you who live by your wits forever,
Hecate of the crossroads.

Ann B. Knox

AUNT FROM THE COUNTRY

The wedding was perfect, heirloom
dress, the groom somber with joy.
Later, an aunt from the country grew
bawdy and danced with a waiter until
the band packed up. She'd driven home
singing to herself, recalling music,
her body's sway, young men leaping,
lofting a blue garter. His hand
had been hard, sweaty, and he'd
held her eyes even as young girls
twisted around them. She remembered
ceremony and the falling away of ceremony,
how, without gloves, she'd felt flesh,
and for a moment hunger hollowed
her body like the suck before
a wave that drains mudflats,
exposes a hull slick with weed,
a shimmer of fish flailing the surface.

On the porch next day she smelled
dry rot she'd not noticed before,
like a barn abandoned or hay left
too long unturned. With a J-bar
she pulled the weathered plank,
it lifted with a cry, carrying
rosettes of puncture wounds.
She planed a fresh board, its grain
pink, surface smooth, the corners
she squared, and her hammer hit clean
as nails took the wood, the last tap
neat as the click of a goat's hoof.

She stood, arms crossed, hugging
herself. The plank gleamed, wind
sharpened carrying the smell of salt.
It was a fine wedding, good to dance,
good, the waiter's small curved smile.

BETWEEN FLOORS

Pauli Sandstrom was alone in the elevator when it lost power and bounced to a halt. If its top had risen just a few feet higher, they told her afterwards, they could have pried open the third-floor door and hoisted her out. She behaved like a trooper, like a sport. They clapped her lightly on her shoulders, took hold of her elbows, toted her like a wounded hero down the corridor to her room at Apple Valley Retirement Center.

Silly to call it a top, not a roof, it has its own separate structure, this cage within a cage. "Roof" wouldn't make it seem so low. "A roof over your head," everyone wants that. But a roof refers to outside and Pauli was inside beneath a ceiling, a lighted ceiling that all of a sudden went dark. She'd read in books, "so dark the child lost in the forest/ the heroine trapped in the cellar/ the couple exploring the cavern couldn't see their hands in front of them," and until the power outage she had thought that phrase a cliche. In the elevator's blackness, she'd extended her hand and lost sight of herself. She had felt air rush out with the light, as if someone had put a hand on each shoulder and was folding her in two like a paper doll.

When the lights came on, she pushed "3." She pushed it again. She held each breath to a count, to force air down between her ribs. She pushed "Alarm," and within seconds could hear voices—"Someone's stuck in the elevator." This from two or three people.

"Don't worry, whoever you are, we'll get you out in a jiff." Mr. Hodge, that pomaded voice.

"Is there a restart button on this thing?" That college girl who comes in mornings, Franny Something.

"Don't worry—"

"Hello, who are you in there?"

"Franny, it's me, Pauli Sandstrom."

She repeated her name three times before they heard her. Then Mr. Hodge explained, shouting down to her in syllables: "We have to reach the e-le-va-tor com-pa-ny to find out how to re-start the lift. Just be pa-tient, Pau-li, it won't be too long."

Her breathing steadied. She avoided looking up at the low ceiling or toward the closed door. Looking down, she realized she held a book in her hand, the book she had taken to breakfast in hopes that she would find a table to herself and could read quietly, a mystery she thought she had solved. She'd gotten shivers when she guessed the pharmacist did it. The floor was spotty with dirt, but Pauli held onto the railing and lowered herself into a sitting position, her knees up, her skirt tucked over them, and opened her book. She had thirty-four pages left. She read slowly, fingering the words, the way Mr. Hodge was talking to her.

▽ ▽ ▽

Pauli thought she should sleep with her light on to dispel the memory of being trapped in the elevator, even though they had freed her "in thirteen minutes to the second," Hodge bragged. She hadn't had time to finish her book. On the other hand, her light might draw an aide into her room to check on whether she was all right—"all right," their euphemism for still breathing. She compromised. She read an hour past her usual time, finishing the one mystery—it was the pharmacist, she knew it, trying to cover up his night of incompetence—and beginning a V.I. Warshawski that she had found mixed in with a box of inspirational titles.

When she turned off the light, she lay waiting for her breathing to quicken, her chest wall to fold in on her the way it had in the elevator, the way she remembered huge, bronze Cathedral doors closing slowly against the sun. She had been standing in the entryway, fingering sculpted devils, craning to look up at angels, when the priest pushed the doors in towards her. She had had just enough time to step away from their closing, to turn into the cool church and observe the service.

"Tonight," she told herself, "if I feel I'm suffocating, I'll just picture those cool shadows, light coming through stained-glass clerestory windows." But when she turned out her lamp, her breathing remained steady and deep.

Meredith called her before breakfast. "I'll come by after work. Will you be okay until then?"

"I thought Hodge would've hushed it up," Pauli told her daughter.

"He's concerned, Mother. He thought you might want to move to a first-floor room."

"He's afraid I'll sue."

"I hate it when you get cynical. I'll feel better if I see you—"

"It's Friday; traffic's awful, and as a matter of fact—"

—as a matter of fact, Pauli thought while Meredith's voice scolded on, it was lovely, an air pillow, that barely perceptible bouncing, that stillness, that knowing no one could enter.

▽ ▽ ▽

In her room, halfway down the hall and across from the broom closet, Pauli felt like a sitting duck. Maids came in because she was one of the few residents to leave them tips, and they were grateful and wanted to give her the socializing they said she required.

Residents who came to the closet for a roll of toilet paper or light bulb stopped by her room to visit—Josie, during her daily mile, nine times fire exit to fire exit and a half corridor besides, Phyllis to hawk cosmetics and shampoos. "I've this special conditioner, Honey; thicken your hair in two weeks." Serena, whose room was right above Pauli's, would knock and then stand peering in from the doorway, saying nothing. Pauli thought she heard Serena crying at night, but the one time she asked about it, Serena said it must have been the TV.

This morning, Craig stopped by after breakfast, an extra muffin for his midmorning snack in one hand. He put his other hand on her shoulder and leaned his head down to look into her eyes. "Just want to make sure you're not all shaken up," he said, but she saw another question in his eyes. Some days she wished he would ask it, so she could say "No," be through with his visits, his crumbly chin, his edging closer and closer to where she sat on the bed. She thought that maybe she should say something first, but she couldn't face the embarrassment if he claimed, "Why, Pauli, I'm just being neighborly, what kind of thoughts are those for a woman like you to have?"

She waited until past 9:00 p.m. to step into the hallway and ring for the elevator. Alone inside it, she pushed "Stop" between the third and fourth floors. She knew that the elevator could not move if the door was open, and so she wedged a soup spoon that she filched at dinner into the split of the door—a detective's trick she once read. It took surprisingly little strength to pull the doors a sliver apart. She worried that an automatic alarm might sound. None did. The light remained on. Pauli opened her book.

▽ ▽ ▽

They chose Apple Valley because the center had a nursing home next door to the retirement rooms where Steven, Pauli's husband, could recover from his stroke. Meredith said it would be peace of

mind for Pauli—"What could you do, Mom, if the plumbing backs up? If mice eat through your phone wires? Or a stranger comes to the door at midnight?"

Pauli agreed, afraid of mice and strangers and the costs of independent housekeeping—they could get a special rate on Steven's care if she moved into Apple Valley with him.

"—and think, new friends and daylong excursions." Pauli thought of Merry's stories about summer camp, stories Merry told only years later at a family dinner when all the cousins were dredging up miserable times in childhood—forced swims in a frigid lake, lumpy oatmeal.

They planned that when he could do some things for himself, Steven would move into her double room. Deep down, in a place with barely enough light for Pauli to examine the truth, she counted on his not recovering. For years before his stroke they had lived side by side in silence until Pauli felt too old, too long-married even to conceive of separation. She only savored the thought now because his stroke had separated them, and her peaceful evenings without him felt like thick, scented balm.

Pauli didn't want Steven to die or to linger like an over-boiled vegetable, unable to speak or brush his teeth or twist shiny metal into homemade sculpture. He had been a plumber by trade, an apprentice to his father right out of high school and gradually taking over the business, but for years—he started when Meredith was a toddler—he would bend soft copper tubing or weld leftover pieces of brass pipe and anything else he could find into fanciful shapes.

Pauli couldn't forget the one-speed bike she found in a garage sale. She would pedal the neighborhood in a zigzag grid, admire a blaze of azaleas here, a hammocked porch there, imagine someone inside a bay window envying this woman who was singing as she rode along, curving her bike in S's the way little boys up the block did. One night Steven went out to the garage, and came back two hours later with a clown for Meredith. Merry laughed so hard, Pauli couldn't cry. He had used the pedals on her bike for the clown's ears. The replacements he found clanked at each rotation.

She was ashamed that years ago she had been attracted to his mean-streaked sense of fun. She had felt protected by it until he turned it against her. Even so, Pauli wanted Steven to recover enough to give shape to his imagination, if only with pipe cleaners; to turn a magazine page, to walk with a cane if necessary up and down the halls. Just not enough to share her room. No one in

the Center knew how Pauli felt. She went to sit with Steven for an hour every day. His nurses smiled at her in sympathy.

<center>▽ ▽ ▽</center>

The broom closet was never locked. One night, Pauli stopped to pick up a can of cleanser and a sponge that she dampened at the utility sink. Inside the elevator, she scrubbed away the spots on the floor. While the floor dried, Pauli stood admiring the reclaimed pattern in the tile.

Pauli took pleasure in housecleaning she could see—in Steven's eggy dishes washed and draining. In plants watered and the crackling of dried leaves in her fingers. In furniture dusted and magazines fanned out. She loved the quiet, Steven at work and Meredith at school, when she could stand motionless looking inside at the room she had fluffed up, or outside through glass so clear it seemed she could step through and walk away.

The one time she tried walking away Meredith found her, like a bird stilled in flight, standing motionless in front of her closet, as if she were deciding which dress to put on. Her open suitcase lay on the bed, full of underwear and sweaters.

"My God, Mom, you look catatonic," and she shook Pauli, the way someone might shake a child to rouse her from a deep sleep. "How long have you been standing here?"

Pauli didn't know. The clothes had blurred into a dark paisley that disappeared against the wall and all she could see was a row of empty hangers.

"Did you want me to find you this way and talk you out of leaving—" It seemed to Pauli that everything Meredith said to her since was coated with that same scorn—"so you could blame your troubles on me? You had all day to get out. Why didn't you?"

Pauli couldn't answer her. All she remembered was opening the closet and then freezing in front of it, the way she did when she was a child playing "statue," everything going out of her head except the need to hold whatever posture she'd been caught in when the leader cried "Stay!"

But Meredith didn't wait for an answer; she went to a friend's for the night. That winter Meredith developed a crush on her math teacher, a young woman who wore jeans and hand-painted silk blouses, and who, rumor had it, could cut down an insolent halfback or computer jock with a hard stare. Meredith saved for months to buy a blouse like Ms. Randall's and entered college as a math major.

When Pauli was helping Meredith pack for college, she saw

the packets of birth-control pills. She suspected Meredith had put them where Pauli would have to see them. Meredith said, as if it were the most natural thing, "Ms. Randall thought I ought to go to school prepared." Pauli didn't resent the teacher, she rued her own insubstantiality. How could Merry look to her for anything if she cast no shadow?

▽ ▽ ▽

The morning after Pauli scrubbed the elevator floor, she sat on it working the crossword puzzle from the morning paper. She had taken to stopping the elevator when residents were gathered in the recreation room for armchair aerobics or TV watching, or for the first twenty minutes of mealtimes. She worked puzzles, read, sometimes knit. Each time the car jounced and stopped, Pauli's breath caught on her secret, and her split-second panic vanished in the pleasure of her solitude.

▽ ▽ ▽

On Saturday, she skipped her visit to Steven and rode the Center's van downtown. Perhaps with the weekend crew on duty no one would call to ask why she hadn't come to see him. The nurses claimed they were worried that something had happened to her when they called. She didn't believe them. She thought they had become Steven's advocates against her independence, the way neighbors reported back to her mother whenever they saw her out alone after dusk. Downtown, she bought a new detective novel. The clerk tried to talk her into a clone of Miss Marple, but Pauli was giving up sweet old things who conceal their wit in their shopping bags. In the book she bought, the young, blue-jeaned detective has moved to a one-room loft. She has to let down a ladder for visitors.

▽ ▽ ▽

The morning Mr. Hodge caught her, she was sitting in the elevator writing her oldest friend, Izzy, so absorbed in what she was telling her—the way she used to sit in her bedroom for hours, only a night-light on, talking on the phone to Izzy while Steven slept in another room—that she didn't hear the spoon clink to the floor. "Pauli Sandstrom, what in the world— Are you all right?" and Mr. Hodge was in the elevator, his hand on Pauli's arm half-lifting, half-pulling her up. Meredith arrived an hour later and was closeted alone with Mr. Hodge because Pauli refused to join them. "He makes me feel like I've been sent to the principal's office."

When Meredith came up to Pauli's room she looked stricken

and her voice sounded ragged, as if an emery board had been filing her throat. Pauli wanted to put her daughter's head in her lap and tell her everything would be all right, but Pauli didn't yet know the extent of what was wrong.

"He thinks you are having a nervous breakdown, Mother, or worse, an onset of Alzheimer's, and that it isn't safe for you to live here without close observation. I told him—"

"What did you commit me to?"

"—I would guarantee—"

"What did you promise I would do?"

"I—All I promised was that it won't happen again."

"How do you know it won't?" Pauli asked, surprised at her own tenacity.

"I don't. But if it does, we're in a mess of trouble. Do you want to go live next door with Dad?"

"I'm not crazy, I am not disoriented, I am—"

"What in the world were you doing in that elevator?"

"I was writing a letter to Izzy." Even Pauli could hear how bizarre that sounded. She had a fleeting vision of Meredith giggling and then Pauli joining in and the two laughing so long and so loudly that someone would report them to Mr. Hodge, and he'd come up and then they'd laugh some more.

"What I don't understand—" Meredith was putting on her sweater. She never said good-bye, just put on her jacket or sweater, leaned down for a kiss and went. "—is how come you didn't pound the walls of that elevator? You used to get claustrophobic in my bathroom."

"That," said Pauli, "is what I was trying to figure out in my letter to Izzy."

▽ ▽ ▽

"I think what it is," Pauli began her letter, "is that one anxiety scares away another. Like the time I climbed the monkey bars because Merry couldn't get down by herself. Or when you and I got lost in town and scrambled into that sleazy bar because those guys were hounding us—"

Pauli knew Izzy would remember too the smell of stale smoke and cheap wine, the surprisingly crisp taste of the cold beer the bartender gave them, one they paid for, one on the house, and his worrying over them because "these streets aren't safe for ladies like you."

In her room, she tried again to tell Izzy what she felt, but her

elbow was sore from Mr. Hodge's yanking it, aggravating the arthritis in her fingers. It hurt her to keep writing. Maybe while Pauli still had the double room to herself Izzy's son or daughter-in-law would drive her down for a visit. If she could walk arm-in-arm with Izzy again, talk to her at dinner, she wouldn't seem like such an isolate.

<p style="text-align:center">▽ ▽ ▽</p>

Steven's eyes were open when Pauli went to sit with him. She described the early spring—the crocuses were already gone. The nurse came to check his pulse and IV drip, and squeezed Pauli's shoulder as she left the room. Pauli began the speech she had been practicing each night before she fell asleep and once a day in the elevator. If she missed a sentence, she made herself start over again. She had the wild thought that it would free Steven from his own skin, the way seclusion in the elevator was slowly freeing her.

"Steven, I won't be coming in every day. I would do whatever I could to help you get better, I hope you know that, but I do not believe my coming here helps you. It does not help me. When I leave, I don't think how hard this stroke is for you, only of how miserable we were together. I think you must sense that."

She had edited out all the wretched details, certain that if his brain still had memory, he could recall his version as easily as she could hers; and that if it didn't, it was no kindness to remind him. That after those early years of romping sex in rooms they had just painted oyster-white, or on warm dark nights in crabgrassed yards they had surrounded with grapestake fences, their differences took root. Her marriage seemed to her like the volunteer hawthorne tree, a dozen feet high before she connected those showy white flowers in spring with the stench, worse than any at the dump.

They came down flat-footed on either side of anything that came between them—money and Meredith, the fish she cooked and the reruns he watched, presidential candidates, and each other's friends. He cut off every argument with "I'm in people's fucking shit all day long—I don't want any more at home." The first time he yelled like that, she was so shocked at his using that language with her, she went into the bedroom and cried. Sometimes, after she learned to brace herself against his explosions, she would mutter in his presence, other times lock herself in the bathroom. One night, Meredith grown and away at college, he shouted and she ran the water full tap in the kitchen sink, it would have drowned her out if she hadn't yelled back so hard her chest hurt afterward—

"See, there's no sewer backup in this house, no fucking scum, no shit, not until you bring it in with you." It was his turn to be shocked. They never fought again.

"I would like to sit here, talk about the good times, skinny-dipping that first summer we were married—but, see, everything I think of has an unhappy ending. Remember, the sheriff caught us and forced us to dress in front of him, I put my blouse on inside out? We never did anything like that ever again. So I think it's better for me not to come."

She didn't say what else she was thinking, that if it were her body imprisoning her, the claustrophobia would crush her into madness, that by removing herself, she believed she was giving him air—

—she flung back the sheets, rolled from the bed, ran out the door and up to the first-floor landing before her breath touched bottom, before she knew where she was. Barefoot and gowned, she sat on the stoop. Air, she needed air—

They were in London at a bed-and-breakfast, the last stop on their three-week trip to Rome, Venice, Paris, Brussels, London. Steven had had a windfall year, Meredith was off on her own, all their friends had traveled to foreign countries, selected exotic foods from pots simmering in the kitchens of small restaurants, drunk local piquant wines, come home with souvenirs and stories of re-kindled romance. Pauli saw it as their last chance.

He wouldn't eat the snails and she wouldn't try the mushrooms and when they each got sick, the other said "I told you so." She went off alone to cathedrals while, so far as she could tell, he spent half his days under the sinks in their rooms. The one time they made love—they had spent all afternoon looking at sculpture, Rodin and Henry Moore and Brancusi—their bed squeaked so she was ashamed to go to the hotel dining room for breakfast in the morning.

The bed-and-breakfast in London that friends had recommended had only one room available, a low-ceilinged basement room. "Cozy," she'd said to the manager. "Yes, love, and warm," the woman had replied. And then Pauli had gone to the British Museum while Steven went to the Victoria and Albert. She saw mummied pharaohs and read the wall legends that told of wives buried alive.

The front door had locked behind her. Pauli sat in her night-gown, shivering on the stoop until daylight when the housecleaner

came. She stepped inside, the hair on her arms still cool. Now in Steven's room, Pauli remembered what she put out of her mind that morning in London—the figures on the frieze, their heads and feet sideways as if to walk, their bodies full front.

▽ ▽ ▽

The following week, instead of visiting Steven, Pauli rode the van downtown and treated herself to something different each day—library Monday, City bus ride Tuesday, the first bus that came along. She rode it for an hour and then got off and took another one back. Matinee Wednesday. Thursday she bought an answering machine. She turned it on even when she was in her room so that she wouldn't have to answer any-old-someone's ring.

Friday when she got back to her room, she noticed first that her answering machine light was blinking and then that Meredith was standing by the window.

"You lock yourself away like a crazy woman, you won't answer your phone, and now you run away like a little child—" Pauli was trying not to listen to her daughter scold, and that way to give herself time to think of what to say. She was afraid that unless she could take some deep breaths, she would commit herself to something terrible.

"I didn't run away. Don't say that. I didn't run away."

"Don't take me so literally, you know what I mean, you ran out on your responsibility—what do you call that?—every day flitting around downtown, and Dad alone, and in the evenings—"

Steven's nurses must have complained to Mr. Hodge, and he must have checked with the driver of the van.

"I can't be the only one to remind Dad he's still human. Some days when I'm driving out here feeling miserable about him and so exhausted I'm afraid I'll get into a wreck—"

Pauli wanted to say, I'd rather you came less often and with more cheer, your sense of duty crowds me, but Meredith was not looking at Pauli, she was confessing, not inviting interruption.

"—I remind myself how hard this must be for you. I'm not insensitive." Meredith's voice lost its high tightness, as if she had loosened the strings in her throat. "I know how unhappy your life with Dad was. It was probably terrible, but it's too late to fix all that now. I can't help it that you muffed up those other chances when—You always told me if I broke something I had to pick up the pieces. Well, you chose him, Mom. Maybe all you broke was yourself, but all those years, you chose to stay—"

Broccoli or spinach, roses or camelias, twin bed or double, choices in a cage. The choice was whether to get in; once in—

"Let's go out to dinner, Merry, so we can talk."

"Maybe on the weekend."

"Why not now? Hodge will be after you to get me to do—"

"What's so difficult about sitting with Dad every day?"

"I don't owe you an answer." When Pauli raised her voice, Meredith got up to close the door. Pauli watched her to see if she'd reach for her jacket. She didn't.

"Give me some time, Merry—"

"For God's sake, Mom, don't start calling me 'Merry' again."

Pauli stood up then and picked up her daughter's jacket.

"You go sit with your father tonight. Leave me alone. It's still my room and I'll do the door closing."

▽ ▽ ▽

"Don't call me something I'm not—I'm not merry, I'm not your merry-berry, cheery-dearie, happy-go-lucky little girl any more, if I ever was. Why did you give me a name that says what I'm supposed to be?" Meredith was a sophomore in college.

Now, all these years later, Pauli had a response—You never called me anything but Mother. I am your mother, but that's all the name you'll let me own. Before I got married, at work I was Miss Stoker, and when I worked at the voting booths every election I became Ms. Sandstrom, and when I went out with Izzy and my other friends, I had my own name, Pauli, every Tuesday on what your father called my "Girls' Night Out." And for two months once, the year you went off to summer camp, I had a lover who called me Pauline.

▽ ▽ ▽

Mr. Hodge told Pauli that the psychologist thought it would be healthier for her to move downstairs to a single room. The double room offered her false hope that Steven would recover soon. That was why she had stopped visiting him, because she was denying his paralysis.

He smiled and folded his hand over her shoulder. On the first floor, the elevator opened across from the receptionist's desk. The clerk there would know if she entered, could check the lit numbers to see when she left. She wondered if the fire doors locked automatically, if once she slipped into the stairway to walk up, she could get back out. She wondered how cold the stairways were, how bright the lighting in them.

Meredith began coming three times a week to sit with her father. Some visits, she brought Pauli gifts, a small espresso machine so Pauli could brew her own coffee, a paperback mystery with a lurid cover, a waist pack so Pauli wouldn't have to worry about a purse when she walked downtown. Meredith asked if Pauli would like to spend a weekend at her apartment. "It would do you good to get out. This room seems small to me."

Outside Pauli's window a semicircular wrought-iron fence enclosed a platform wide enough for two large planters and Pauli. Some nights she climbed out her window to stand there. With her back to her darkened room, she felt weightless. She thought of climbing over the fence, too, jumping onto the grass and going for a long dark walk. She could drop her desk chair down and use it to climb back up.

"Yes, it is small. I would like to get out once in a while."

She could, but she knew it was an elaborate scheme. She'd go to Meredith's. At the Center when she was wakeful, she would stand on her mock balcony, her hands, like a navigator's, on the railing, and breathe in the fresh air, down to her toes, out to her fingertips. She would trace the street light coming through the trees, through her, into her room.

Joanne McCarthy

RIPENING
It is sad to grow old, but nice to ripen.
—*Brigitte Bardot*

What she regretted was her skin, folding in
on itself like fabric, elasticity gone. Life-
juice that plumped her cheeks disappeared,
wrinkles cast their fine net across her
face, laugh-lined her mouth. Her eyes deepened.
The hairdresser warned her about the gray.
Leave it, she said, I want to see
what Nature will do. What Nature did
was remind her that ripeness
is all, that autumn is the richest
season, that preparing for snow means
building a shelter, that warmth within
withstands whatever winter howls without.

When the baby laughed, reached for her breast
even though milk had been gone for years,
she remembered sweet burdens of motherhood,
relinquished them gladly, her destiny
now another—grandmother, wise
woman, matriarch. The brain
holds what I am, she said, knowing then
that body was always hers. The heart
holds what I would be, the womb can rest.
She saw her life, and knew that it was good.

Carol O'Brien

ESCAPEE

Upstairs, out of the "House" house and into the trees.
It's time to turn inside out.
Here, where my old babies blossomed,
I set back my clock—
Am not too late to dream.

No mirrors needed here,
No face—no past—no days ahead of life and wife.
Nobody knows my name.
Upstairs and out of the "House" house
I ascend into heaven.

CLIMACTERIC

"They" mourn the death of birth approaching—
Age atrophies the gift of Eve. But "She,"
no longer shedding second skins in dread—
Like Lazarus—begins again to breathe.
Her graying womb falls gaily on its sword—
The carmine river, crested, disappears.
Mythologies of drought and dearth explode,
and from the ruins flow her fertile years.

Barbara Lucas

OLD WOMEN

They bend to an unseen bowstring,
tensed and waiting for release.

Tired of staring into the moon,
paying its monthly tribute of blood,
they turn back to the plainsong
of the grass
that their first bodies knew,
relearning the horizontal:
the snake's-eye view of history.

The windows of their spines are open,
wind and light flooding
the empty rooms.
They are becoming their own sky.

That's why we call them witches,
why we fear their question-mark
bodies and what we see
reflected in their eyes:
dark hallways to that first,
abandoned home.

THE MOTHERS

The wind shakes strange music
from the trees tonight,
pulse of branches gripped in ice,
frozen laughter of lost years.
I can't enter this inhuman whiteness
of moon and snow.
They are watching:

Helen stirring somnolent thighs,
Mary walking backward into her shadow,
Kali wearing her lovers' heads as jewels,
Diana giving her breast to the moon,
Cybele gripping the lion between her legs—

these strangers that I once was.

I don't know you, I tell them.
I play the roles, but I'm not the part:
I'm the whole.

Laughter of cracking ice.
We're your mothers, they whisper.
You lived in us; we died in you.
Tonight, daughter, you sleep inside,
but tomorrow when the blood runs dry,
you'll come with us
into the ice-age of the mothers
and a stranger will lie in your bed.

SUNSPOTS

The late afternoon sun makes islands
across the winter lawn—
spots of time, I call them—
somehow more intense
than the great swathes of summer.
The light enters me, filling dry wells
until I become my own sun.
My fifty years flare to corona
and I walk in a body of gold—
my nuptials to winter.

But I know I can't live on islands.
I must cross their blue borders
into the slashed eye of wind
and ululation of brown leaves.
Whatever I've conceived
must be born into this cold.
Women who choose islands
also choose the sea.

Rachel Loden

ICE AGE

The sun shines, but it's not so simple.

Through Siberian summer
the mammoth sleeps,
its huge tusks
locked in ice.

You are bereft, but you are grateful.

You live your life without elaboration,
build a cabin
on the frozen earth,
do your best with children.

You have survived: tough, inconsolable.

Calm only puzzles.
You wait
for the next loss, wondering
how to be content with happiness.

The ice thins, but it's not so simple.

You are the hollowed stone
after the glacier passes on,
your scars
bleached striae in the sun.

Elizabeth Claman

HIGH DESERT

In my mind's eye I see the campsite near Table Rock where my lover and I spent time. The dust is a creamy pale sienna in the sunset glow, and from it the buckwheat flowers, sagebrush, and juniper trees grow with the kind of vigor that makes each one unique. Here, there is no lodgepole regularity, but instead the writhing individuality of trees and scrub and rock pushed and pulled by adversity: extremes of heat and cold, abrupt rains, long droughts. The colors of this landscape are deceptively pastel—the delicate buckwheat yellow and white, dusty sage green, the deeper, more sulfured hue of the junipers with their silvery trunks and gnarled branches, sifting the fragile warmth from the evening sky, which stays golden pink, even as the full moon rises, gleaming through the topmost branches. Most striking of all in my memory though are those gnarled branches themselves, the twisting whorls of wood gone wild, speaking their gestures, each in some unpredictable manner, like no one and nothing else. They are beautiful without a touch of facile prettiness. They are beautiful in the way that I will be as I grow old.

CONTRIBUTORS' NOTES

BETTE-B BAUER says that menopausal zest has propelled her back to school where she is getting a Ph.D. in English Lit. at the University of Oregon. She writes, "I welcomed this stage in my life and thus had a delightful passage without subscribing to ERT; turning 50 infused me with greater permission to just be myself spontaneously in the moment." The condition characterized by white spots which she describes in her piece is known medically as "VIN 3." Apparently common among middle-aged women but without any known cause, it is treated in a way similar to basal cell cancer.

JUDITH BISHOP earned a degree in writing from Columbia, and on graduating, won the Academy of American Poets University Prize judged by W.H. Auden and Marianne Moore. Although originally from the east coast, she has been living in California for the past twelve years, where she has a "simple job" and writes steadily. Her work has been published in various literary magazines and anthologies, including *Kalliope, Taos Review, Stone Country,* and *Mildred.* In 1990, she won the Sri Chinmoy Award, and in 1991, the *Five Fingers Review* chapbook competition.

LAURE-ANNE BOSSELAAR grew up in Brussels, Belgium, and speaks Flemish, French, German, and English. After teaching French Literature in Europe, and publishing a book of French verse, she moved to Colorado in 1986. She assisted Carolyn Forché in translating the poetry of Robert Desnos for Ecco Press, and is currently, with her husband Kurt Brown, translating the work of Belgium's leading poet, Herman de Coninck. Her own poems have been published in *Verve, Hayden's Ferry Review, Denver Quarterly, International Quarterly* and *The Bellingham Review.* In 1993, she won the first prize in the 49th Parallel Poetry Competition. She has three children, and lives in Snowmass Village, Colorado.

ELIZABETH CLAMAN's poetry chapbook, *Peripheral Visions* was published by Five Fingers Press in 1989. The same year, she won the Grand Prize in Negative Capability's Eve of Saint Agnes Poetry Competition judged by Diane Wakoski, and in 1991 she received a grant from the Oregon Institute of Literary Arts. Between bursts of poetry and fiction-writing and various editing projects, she enjoys working on literary and academic translations. In 1992 Columbia University Press published her co-translation of French historian Jacques Le Goff's *History and Memory,* and she is currently at work on a Ph. D. in Comparative Literature at the University of Oregon, writing her dissertation on the aspects of poetic language which resist translation.

MARCIA COHEE celebrated the publication of her hundredth poem back in 1991. She has an MFA from the University of Massachusetts, and currently lives in Laguna Canyon, California, with her husband and six year-old daughter, Devin. Two books of her poetry have been published, *Sexual Terrain* (1986), and *Laguna Canyon Was Once a River* (1991). She

and her husband run the Laguna Poets Reading Series, and edit occasional issues of the magazine, *Speakeasy*.

MARION COHEN has written and published a lot on the subjects of fertility, pregnancy, home schooling, babies, living with a chronically disabled partner, and loss. She has also been a mathematician (Ph. D. from Wesleyan University), affirming that math inspires much of her writing. A staunch feminist, she has a recent book out from Liberal Press in Texas, called *Not Erma Bombeck*, on mothers as an oppressed class. In her spare time, she loves to sing and to thrift shop.

VALERIE NIEMAN COLANDER is city editor of a small daily paper in West Virginia, and co-editor of the literary magazine *Kestrel*. Her poetry and fiction have appeared in *Poetry, New Virginia Review, New Letters*, and *CALYX*; her chapbook, *Slipping Out of Old Eve*, was published in a special edition of *Sing Heavenly Muse!* and she has had work selected in the PEN Syndicated Fiction Series. She has received awards from the National Endowment for the Arts, The Kentucky Foundation for Women, and the West Virginia Arts and Humanities Commission. She has recently finished a novel, *A Survivor's Affair*, and is at work on another.

LUCHA CORPI was born in Mexico in 1945, and moved to California in 1964. She holds a B.A. from the University of California at Berkeley, and an M.A. in World and Comparative Literature from San Francisco State University. In 1980, she received a writing fellowship from the National Endowment for the Arts. She is a founding member of Aztlán Cultural/ Centro Chicano de Escritores, and served as its president from 1985 to 1987. She has been widely published in both fiction and poetry. Her books are a novel, *Delia's Song* (Arte Público Press, 1989), and two volumes of poetry, *Palabras de mediodía/Noon Words* (Fuego de Aztlán Press, 1980), and *Variaciones sobre una tempestad/Variations on a Storm* (Third Woman Press, 1990).

SUE DORO lives in Oakland, California, where she moved when she "retired" after 13 years as a machinist for the Milwaukee Road Railroad when the company was sold to the Soo Line in 1985. In search of a mid-life adventure (instead of a mid-life crisis, as she tells it), she became the Executive Director of Tradeswoman, Inc., an 11 year old not-for-profit national organization for women in blue collar non-traditional jobs. It publishes a quarterly magazine by the same name, for which she has been the poetry editor for the past 5 years. Her own poetry has been widely published, and has been used in Women's Studies curricula at such universities as Harvard, Rutgers, and the University of Michigan, as well as in literacy programs in the San Francisco bay area. Her earlier collections of poems, *Of Birds and Factories* and *Heart, Home and Hard Hats* have been followed by *Blue Collar Goodbyes*, recently re-issued by Papier-Mache Press.

Over the past year, **JEAN ESTEVE** has had poems accepted for publication in *Carolina Quarterly, Florida Review, Fine Madness, Byline, Mind in Motion* and *Denali*, the publication of Lane Community College in Eugene, Oregon, where her piece, "Oregon Roadside," won first prize in the 1993 contest.

C.K. FREEPERSON has been writing political poems for 20 or more years, and has been widely published in anthologies and magazines. Her most recent contributions have been to *If I Had a Hammer: Women and Work*, (Papier-Mache Press), and *Women's Voices*. In 1986, *The Dream Book, an Anthology of Writings by Italian American Women Writers* appeared from Schocken Press, and won the 1986 American Book Award. Currently, she is working on a novel, parts of which have been previously published as short stories.

JEANETTE ERLBAUM GOLDSMITH writes both short fiction and plays. Her stories have appeared in numerous publications, including *Voices of Brooklyn*, edited by Sol Yurick, and *Commentary*. She has also received a variety of awards for her writing in both genres, one from the third annual NEA/PEN Syndicated Fiction Project, and a CAPS Grant for fiction. She is currently a member of the playwrights' workshop at Wings Theater in Manhattan's Greenwich Village. But foremost among her many achievements, she says, are her four adult children and a growing number of grandchildren.

GRACE GRAFTON is 53, mother of two grown people, a poetry teacher with California Poets in the Schools, where she has worked principally with primary students over the past dozen years or so. She has had many poems and a few prose pieces published in the last 17 years.

BARBARA HOFFMAN has been published in *Beloit Poetry Journal, Blue Mesa Review, Gryphon, Passaic County Anthology, Long Island Quarterly, The Long Islander, Aura Literary/Arts Journal*, and *The Minnesota Review*.

ELISABETH HOLM once developed and taught a college course called "Letters and Journals: The Lives of Women in Their Own Words." She took the Ph. D. at 58 and is retiring in the northwest to enjoy reading, watching the sky, riding her bike by the river, and being with big trees. She is beginning to write her own life and getting ready to hold some grandbabies.

MURIEL KARR was born on Mother's Day in 1945. She used to teach French and German. Now, she lives and writes in Mountain View, California.

LINDA KEEGAN, a New Hampshire native, has taught watercolor, piano and guitar over the years, and has also worked as a paramedic. She has held a writing residency at Yaddo, and her poetry and short fiction have appeared in numerous journals, including *The Pittsburg Quarterly, New Virginia Review, Zone 3*, and *The Cape Rock*. These days, she lives and writes in McMurray, Pennsylvania.

ANN B. KNOX edits *Antietam Review*, a literary magazine in Maryland. Her work has appeared in *Poetry, Alaska Review, Negative Capability, Plum Review* and *Nimrod*, and her book, *Stonecrop*, was the winner of the Washington Writers Publishing House Award.

PHYLLIS KOESTENBAUM has received grants from the National Endowment for the Arts, the Santa Clara County Arts Council, and the Money for Women/Barbara Deming Memorial Fund, Inc. Some of her recent work has been published in *Epoch, Poetry New York, Brooklyn Review*,

Poet Lore, and *The Best American Poetry 1992* (Charles Simic, editor), and is forthcoming in *The Best American Poetry 1993* (Louise Glück, editor). Her books are *oh I can't she says* (introduction by Robert Hass), Christopher's Books, 1980; *Hunger Food*, Jungle Garden Press, 1980; *Crazy Face*, Mudborn Press, 1980; *That Nakedness*, Jungle Garden Press, 1982; and *14 Criminal Sonnets*, Jungle Garden Press, 1984. Ms. Koestenbaum is an Affiliated Scholar at Stanford University's Institute for Research on Women and Gender, and teaches Creative Writing and Composition at West Valley College in Saratoga, California.

WENDY WILDER LARSEN was born in Boston, moved to California when she was 6, and has been travelling ever since. Her book of narrative verse, *Shallow Graves: Two Women and Vietnam*, was published by Random House. Her poems have appeared in many "little" magazines, including *Paris Review, Tendril, 13th Moon, Seattle Poetry Review* and others. She is on the board of *Poets and Writers* and Poets' House, and on the Photography Committee of the Museum of Modern Art in New York. In 1993, she won third prize in the Ann Stanford poetry competition.

GAYLE LAURADUNN's poems have appeared most recently in *Tsunami, Zone 3, Conneticut River Review, Puerto del Sol*, and in the Sierra Club Book, *Mother Earth Through the Eyes of Women Photographers and Writers*. She lives in western Massachusetts.

F. R. LEWIS writes in Albany, NY. In addition to receiving two PEN Syndicated Fiction Project awards, her work has been heard on National Public Radio's "The Sound of Writing" series and published in magazines such as the *Alaska Quarterly Review, The Cream City Review, Ascent, The Chariton Review, Cottonwood, 13th Moon,* and *San Jose Studies*. She has been a fellow of both the MacDowell and the Millay Writers' Colonies, and is at work on a novel.

JOAN LINDGREN has taught languages, literature and creative writing along the California-Mexico border for many years. She has worked on oral histories among the Spanish-speaking women in the barrios of San Diego, and has seen the publication of her own poems, essays, and translations of French and Latin American poets. In 1991 she had a Fulbright Border Fellowship to teach Literary Translation at universities in northern Mexico.

RACHEL LODEN's poems have appeared or are forthcoming in *New York Quarterly, College English, New American Writing, 13th Moon, Centennial Review, Yellow Silk, Caliban* and many other publications. She lives and works in Palo Alto, California.

BARBARA LUCAS is the Director of the Poetry Society of America on Long Island, and an editor of *Xanadu*. She is also an associate professor of English at Nassau Community College. Her poetry has appeared in *Beloit Poetry Journal, Kansas Quarterly, Descant, Windless Orchard, Iris, Z Miscellaneous, Confrontation, Crazy Quilt* and the *Albany Review*.

ARLENE L. MANDELL teaches Composition, Literature, and Poetry Writing at William Paterson College in Wayne, New Jersey. A former editor/writer for *Good Housekeeping Magazine*, her poems have appeared in

50 journals and several books in the U.S. and England. As of July 27, 1993, she is also a first-time grandmother.

ANNE MARPLE lives in a condo in West Los Angeles with two cats and at least one foreign student. A fervent on-and-off genealogist, she has collected all of her great-great-grand-parents, missing only two maiden names. (There's a strong chance she's descended from Anne Boleyn's naughty sister.) An Anglophile, she has visited England eight times. Her writing career spans several genres, and she has enjoyed the publication of her work in all kinds of magazines, from *Vogue*, *Mademoiselle*, the *New Republic*, and *Gentlemen's Quarterly* to the literary mags, *Grammercy Review*, *Blue Window*, *Tsunami*, *Blue Unicorn*, *Poetry/la*, and others.

JOANNE McCARTHY is enjoying the happiest years of her life (really). She has had poems in several literary magazines, such as *The Bellingham Review*, *Crosscurrents*, *Thema*, and *Green Fuse*. Her book of poems, *Shadowlight* was published by Broken Moon Press in 1989. She teaches English and Creative Writing at Tacoma Community College outside of Seattle.

Although her work life has been in publishing, **EMILY MEHLING** says her "most satisfying interests and endeavors have been in fiction and poetry." She also sculpts in clay and stone. With a wonderful family, she lives peacefully and by choice in the midst of "the gorgeous chaos that is New York City."

EVE MERRIAM's first book won the Yale Younger Poets prize. Since then, she has published numerous volumes. Her most recent work appeared in *Ms Magazine*, *Nimrod*, *The New Advocate*, *The Decade Dance*, and *Poets On*. She also won an Obie Award for playwriting, and the National Council of Teachers Award for Excellence in Poetry for Children. Eve Merriam died on April 11, 1992.

MARGE MILLER recently celebrated her 27th wedding anniversary, and she has 2 sons, ages 18 and 22. She is the Human Resources Supervisor in a manufacturing firm, and a part-time student at Saint Joseph's College in New York. She has been writing poetry for 15 years, and has published a collection entitled *Fandango*. Her poems have also appeared in several anthologies, including *Zephyr*, *Island Women*, and *The American Poetry Anthology 1988*.

FAYE MOSKOWITZ is an associate professor and Director of the Creative Writing Program at George Washington University in Washington, D.C. She is the author of *A Leak in the Heart* (David Godine, 1985), *Whoever Finds This: I Love You* (David Godine, 1991), and *And the Bridge is Love* (Beacon Press, 1991). Moskowitz has been a contributor to "All Things Considered" on National Public Radio, and to the HERS Column of the *New York Times*. Her most recent work is an anthology of Jewish mothers and daughters.

PADMA SUSAN MOYER lives in Moss Beach, California with her husband and dog. She has a psychotherapy practice in San Francisco. Until she started writing at the age of 41, she had a recurring dream of being a performer like Sandra in her story, "Sequins." Moyer's story, "Hummingbirds," was published in the August 1993 issue of *Recovering* magazine.

CAROL O'BRIEN considers herself a late bloomer. Marrying young, she and her husband have raised four children who are now grown and functioning in their various careers. When the youngest was twelve, she returned to college and received a degree in English Literature from the University of California at Santa Cruz. These days, she works for a local public library as a cataloger, and spends as much time as possible in the Sierra, where a second home makes possible the hiking and skiing she and her family enjoy.

JANE ORLEMAN has been a painter for 23 of her 50 years. In Ellensburg, Washington, she and her husband, artist Dick Elliott, have created an art site, *Dick and Jane's Spot*. She considers her paintings a dialogue with herself, and a way to find healing for the memories of childhood abuse which haunted her. Her paintings have been widely displayed and highly acclaimed throughout the United States.

CHARLOTTE PAINTER has published novels, personal narratives, short stories and poetry. Her excerpt is from *Seeing Things*, a comic vision of California's New Ageism. Her personal narratives include *Who Made the Lamb*, and *Confessions from a Malaga Madhouse*. In *Gifts of Age* she tells the stories of creative older women. *Revelations: Diaries of Women*, which she edited with Mary Jane Moffat, is a classic in Women's Studies programs, adopted in courses throughout the U.S.

DARBY PENNEY is editor of *The Snail's Pace Review*, a little magazine of contemporary poetry. Her work has appeared in *Blueline*, *The Graham House Review*, *The Little Magazine*, and *Negative Capability*, among others, and was exhibited at the New York State Museum in conjunction with a photography exhibit entitled, "Mothers and Daughters."

DANNYE ROMINE POWELL won a National Endowment for the Arts Fellowship for poetry in 1993, and also the University of Arkansas's First Book Award for *At Every Wedding Someone Stays Home*, which they will publish in the spring of 1994. Her writing has also appeared in numerous journals and reviews, including *Paris Review*, *The Georgia Review*, *Prairie Schooner* and *The Southern Review*.

INGRID RETI is a Literature and Creative Writing teacher at California Polytechnic State University Extended Education. Her poetry has appeared in such publications as *Exit 13*, *Poet's Quarterly*, *Phoenix*, and *The And Review*, as well as in a number of anthologies. Her second collection of poetry, *Echoes of Silence*, was published in 1990.

ELISAVIETTA RITCHIE is a writer, poet, editor, photographer, and translator who has read at the Library of Congress and many other venues in North America and abroad. She has published nine poetry collections, and has had individual poems in *Poetry*, *The American Scholar*, *Christian Science Monitor*, *Amelia*, *New Republic*, and many other publications. Her books include *Flying Time: Stories and Half-Stories*, (Signal Books, 1993), which contains four PEN Syndicated Fiction winners, and *The Dolphin's Arc: Poems on Endangered Creatures*, which she edited. Her newest collection of poetry, *The Arc of the Storm*, is due out from Signal Books in early 1994. She divides her time between Washington, D.C. and Toronto.

CATHERINE RODRIGUEZ-NIETO was born and raised in the Midwest. After living for three years in Panamá and one year in France, she settled in the San Francisco bay area, where she and her husband own—and with the aid of a marmalade cat named Raúl—operate *In Other Words, Inc.*, a translation and editing firm.

In the Year of the Woman, **SUSAN SCHEFFLEIN** wrote the libretto for an opera about Sybil Ludington, a sixteen year old heroine, who rode through much danger to warn the militia that the British were attacking Danbury in 1777. The composer of the opera was Ludmila Ulehla of Long Island. Their collaborative work was performed in Manhattan, April 1993, and in Danbury later the same year. Her poems have appeared in several literary journals, including *Pandora, Touchstone* and *The Birmingham Poetry Review*.

In 1992, **WILLA SCHNEBERG** received second prize in the Allen Ginsberg Poetry Awards sponsored by the Poetry Center at Passaic Community College in New Jersey. Her book entitled *Box Poems* was published by alice jamesbooks, and more of her work will soon appear in *Tikkun: The Anthology*, and another anthology devoted to writings about the holocaust. Most recently, she was in Cambodia where she worked with the United Nations Transitional Authority to assist in the conduction of "free and fair elections."

BRENDA SHAW grew up in New England, then lived a number of years in Scotland with her husband. While there, she worked as a scientist and lecturer at Dundee University Medical School. Her scientific writing has been published under her married name. A collection of her poetry, *The Cold Winds of Summer*, was published in Scotland in 1987 by Blind Serpent Press. She now makes her home in Eugene, Oregon.

NOELLE SICKELS has essays and articles in a number of national magazines, and short stories and poetry in several small press anthologies, including *American Fiction 1993*. She was the editor of *Time Was*, a collection of reminiscences by Los Angeles senior citizens, and she has recently completed a historical novel about a women's wagon train.

SUSAN TERENCE is a poet-teacher/performer through California Poets in the Schools in San Francisco. She has received a DeWar's Young Artists' Recognition Award for literature for the state of California in addition to many other prizes for her poetry. Her work has appeared in *Southern Poetry Review, The Nebraska Review, Negative Capability, Lake Effect, Halftones to Jubilee, Atlanta Writers' Resource Journal, Catalyst, San Francisco Bay Guardian*, and other journals. She performs her poetry across the country, and is currently completing a novel.

CELIA TESDALL lives and writes in a university town in the Midwest. At 57, she still has mood swings, period pain, and water retention occasionally, but so far as she knows, she has never experienced a hot flash from first to last.

A professor of English at Castleton State College in Vermont, **JOYCE THOMAS** has special teaching interests in folk tales and children's lit-

erature, both of which she has written about in numerous articles. In 1989, Sheffield Academic Press in England published her study, *Inside the Wolf's Belly: Aspects of the Fairy Tale*. Her poetry has appeared in many journals, among them, *Negative Capability*, *The Southern Florida Review*, *Blueline*, *The Conneticut Writer*, *Mankato Poetry Review*, *Embers*, and *Electrum*.

GLORIA VANDO's poems have appeared in *Kenyon Review*, *Rampike*, *Stiletto*, *Poets On*, *New Letters*, *Movieworks Anthology*, *Women of the Four-teenth Moon*, *Seattle Review* and other publications. Her poetry manuscript was a finalist in the Poetry Society of America's 1990 Alice Fay Di Castagnola Contest. She is the editor of *Helicon Nine*, a magazine she founded and edited for 10 years, and for which she received a CCLM Editor's Grant, and the 1990 (Kansas) Governor's Arts Award. She has served on the Literature Panels for the National Endowment for the Arts, and she is a Poet in the Schools in Kansas and Missouri, as well as a member of the Kansas Governor's Council on the Arts.

DIANE WAKOSKI's most recent collection of poems, *Jason the Sailor* (Black Sparrow, 1993), is the second volume in a larger work entitled *The Archeology of Movies and Books*. The first volume was *Medea the Sorceress* (Black Sparrow, 1991), and Wakoski is at work on the next two volumes, *The Emerald City of Las Vegas*, (the site she sees as most representative of all things American), and *The Argonauts* (the name appropriated in California mythology for the men who came west searching for gold in the nineteenth century). Her selected poems, *Emerald Ice* (Black Sparrow, 1988), won the 1989 William Carlos Williams Prize. She is a Writer in Residence at Michigan State University.

ROSMARIE WALDROP lives in Providence, Rhode Island, and with her husband, poet Keith Waldrop, runs Burning Deck Press. Her latest book, *Lawn of Excluded Middle* was published in 1993 by Tender Buttons Press. She writes that her poem, "Winter Journey," is "about" her mastectomy.

LYNNE WALKER (aka Big Red) has been published in *Wormwood Review*, *Mid-American Review*, *Pig Iron Press*, *The Spirit that Moves Us*, *Painted Bride Quarterly*, *Glass Will*, and other literary magazines. Her two self-published chapbooks, *Big Red* and *Hanging Out With the Big Girls*, have become underground classics. She conducts the Free People's Workshop in Toledo, Ohio.

JULIE HERRICK WHITE got a late start writing, but made up for it when she received a grant from the Indiana Arts Commission for 1992-93. She has had two poetry chapbooks published, *Friends from the Other Side* (State Street Press, 1985), and *Steubenville*. Her collection of short stories, *Uncle Gust and the Temple of Healing* was published by the Writers' Center of Indianapolis in 1991. Lately, she has been teaching Creative Writing to adults, and, "Yes," she says, "I have finally finished with menopause and find the 'other side' pretty good."

HANNAH WILSON was running marathons when she went through menopause—the more she ran, the easier that great life change. She's writ-

ten about most of the important things in her life: running; growing up in Brooklyn; husband, son and daughter, grandchildren; teaching, knitting, baseball, and her dog, Bella. Her fiction and poetry have been published in *Other Voices*, CALYX, *Calapooya Collage* and other small publications as well as in anthologies. She is at work on a long story, told in prose and poetry, about Penelope. She is currently the Fiction Editor of the *Northwest Review*.

DOROTHY WINSLOW WRIGHT is a former Bostonian now living in Honolulu. Her fiction has appeared in a variety of publications in the United States, Canada, and England. A frequent winner of poetry awards (World Order of Narrative Poets, DeLong, *The Inkling*), her poems appear in literary journals such as *Shorelines*, *Manhattan Poetry Review*, and *The Formalist*. For fun, she plays the keyboard, raises orchids, and prowls tidepools in search of the muse.

SONDRA ZEIDENSTEIN's Chicory Blue Press is currently focusing on chapbooks in all genres by women over 60. Zeidenstein calls herself "a late-developing poet" who started writing poetry just over ten years ago, at age 50. About two dozen of her poems have been published, most recently in *Taos Review*, *Yellow Silk*, *Women's Review of Books*, *Rhino* and *Poets On*.